1976

In Memory of

Roger Vornholt

Fantasy & Symmetry

Fantasy & Symmetry

THE PERIODIC DRAWINGS OF

M.C. Escher

CAROLINE H. MACGILLAVRY
University of Amsterdam

HARRY N. ABRAMS, INC., PUBLISHERS, NEW YORK

Library of Congress Cataloging in Publication Data

MacGillavry, Caroline Henriette, 1904-
Fantasy & symmetry.

Reprint of the 1965 ed. published for International
Union of Crystallography by A. Oosthoek's Uitgevers-
maatschappij, Utrecht under title: Symmetry aspects of
M. C. Escher's periodic drawings.
1. Escher, Maurits Cornelis, 1898-1972. 2. Symmetry.
3. Colors. I. Title.
NC745.M3 1976 769′.92′4 75-39835
ISBN 0-8109-0850-6

Library of Congress Catalogue Card Number: 75-39835
Copyright 1965 and 1976 by the International Union of
Crystallography, Geneva, Switzerland

Published in 1976 by Harry N. Abrams, Incorporated, New York
All rights reserved. No part of the contents of this book
may be reproduced without the written permission of the publishers
Printed and bound in The Netherlands

Table of Contents

Preface

Many of the brightly coloured, tile-covered walls and floors of the Alhambra in Spain show us that the Moors were masters in the art of filling a plane with similar interlocking figures, bordering each other without gaps.

What a pity that their religion forbade them to make images! It seems to me that they sometimes have been very near to the development of their elements into more significant figures than the abstract geometric shapes which they moulded. But no Moorish artist has, as far as I know, ever dared (or did he not hit on the idea?) to use as building components: concrete, recognizable figures, borrowed from nature, such as fishes, birds, reptiles or human beings. This is hardly believable because the recognizability of my own plane-filling elements not only makes them more fascinating, but this property is the very reason of my long and still continuing activity as a designer of periodic drawings.

Another important question is shade contrast. For the Moors it was natural to compose their tiled surfaces with mutually contrasting, different-coloured pieces of majolica. (Likewise I myself have always used contrasting shades as a simple necessity, as a logical means of visualising the adjacent components of my patterns.)

These two main rules could briefly be formulated as follows: without recognizability no meaning and without shade contrast no visibility.

I often wondered at my own mania of making periodic drawings. Once I asked a friend of mine, a psychologist, about the reason of my being so fascinated by them, but his answer: (that I must be driven by a primitive, prototypical instinct) does not explain anything.

What can be the reason of my being alone in this field? Why does none of my fellow-artists seem to be fascinated as I am by these interlocking shapes? Yet their rules are purely objective ones, which every artist could apply in his own personal way!

My first periodic woodcut was made in 1922. The original woodblock presents a collection of eight different human heads which can be printed and multiplied by translation.

In the course of the years I designed about a hundred and fifty of these tessellations. In the beginning I puzzled quite instinctively, driven by an irresistible pleasure in repeating the same forms, without gaps, on a piece of paper. These first drawings were tremendously time-devouring because I had never heard of crystallography; so I did not even know that my game was based on rules which have been scientifically investigated. Nor had I visited the Alhambra at that time.

Many years later, in 1935, I came for the first time in contact with crystallographic theories, which I seriously tried to understand. But they were mostly too difficult for my untrained mind and on the other hand they took no account of the shade contrasts which for me are indispensable. So in 1942 I came to formulate a personal layman's theory on colour symmetries which I illustrated with many explanatory figures.

Though the text of scientific publications is mostly beyond my means of comprehension, the figures with which they are illustrated bring me occasionally on the track of new possibilities for my work. It was in this way that a fruitful contact could be established between mathematicians and myself.

The dynamic action of making a symmetric tessellation is done more or less unconsciously. While drawing I sometimes feel as if I were a spiritualist medium, controlled by the creatures which I am conjuring up. It is as if they themselves decide on the shape in which they choose to appear. They take little account of my critical opinion during their birth and I cannot exert much influence on the measure of their development. They usually are very difficult and obstinate creatures.

The border line between two adjacent shapes having a double function, the act of tracing such a line is a complicated business. On either side of it, simultaneously, a recognizability takes shape. But the human eye and mind cannot be busy with two things at the same moment and so there must be a quick and continuous jumping from one side to the other. But this difficulty is perhaps the very moving-spring of my perseverance.

This publication of my periodic drawings represents for me a crown on an important part of my life's work. I am deeply indebted and grateful to Professor C. H. Mac-Gillavry, because the book would never have been accomplished without her kind and flattering interest in my regular plain-filling mania.

<div align="right">M. C. Escher</div>

Introduction

In these days when art and science operate in different spiritual realms which seem to diverge ever more, it is remarkable to find an artist who in his creative work is preoccupied with problems which lie at the base of some sciences and some branches of mathematics. In fact, it appears that for a similar case one has to go back to the time when artists discovered the laws of perspective and pioneered in the field of anatomy.

As Mr. Escher has exposed in his preface to this monograph, one of his preoccupations for long years has been the filling of the plane with mosaics, the elements of which give associations of, and are recognizable as, living creatures. Although this principle does not necessarily lead to repetitive patterns, many of his drawings are indeed periodical in two dimensions.

Of course, every periodic pattern must conform to the symmetry laws dictated by this periodicity. It may, however, be rare that an artist, instead of intuitively obeying these laws, consciously explores them, and applies the various possibilities afforded by them. In the course of over thirty years, Escher has designed well over a hundred of such periodic patterns, using motifs in a large variety of symmetry combinations. Many of the patterns have served him as an inspiration to his graphical art (see e.g. Escher 1960, 1961). Elements from several patterns reproduced in this monograph can accordingly be found in his woodcuts and lithos, where they acquire what the psychologists call an 'extra dimension'.

It is no wonder that X-ray crystallographers, confronted with the ways in which nature solves the same problem of packing identical objects in periodic patterns, are interested in Escher's work. This interest led to the organization of an exhibition, on the initiative of Prof. J. D. H. and Dr. Gabrielle Donnay, during the Fifth International Congress of the International Union of Crystallography, held in Cambridge, U.K., in 1960. It occurred to several scientists attending this meeting that Escher's periodic drawings would make excellent material for teaching the principles of symmetry. These patterns are complicated enough to illustrate clearly the basic concepts of translation and other symmetry, which are so often obscured in the clumsy arrays of little circles, pretending to be atoms, drawn on blackboards by teachers of crystallography classes. On the other hand, most of the designs do not present too great difficulties for the beginner in the field.

Many of Escher's periodic drawings are based on the principles of colour symmetry. The simplest aspect of this, so-called black-white or anti-symmetry, was introduced in the crystallographic literature about 1930, on the occasion of a symposium on liquid crystals. Practically immediately afterwards, the notion of colour symmetry fell into a twenty years 'sleeping beauty' slumber, from which it was restored to life very vigorously by Shubnikov's book on symmetry and antisymmetry (1951). Polychromatic symmetry made its first appearance in the scientific literature about 1956. During this interval, Escher throughout his career has been much preoccupied with the pro-

blem of colour symmetry, for the reasons he has set out in his preface. The notebook in which he wrote his 'layman's theory' has been a revelation to me. It contains practically all the 2-, 3-, 4- and 6-colour rotational twodimensional groups, with and without glide reflection symmetry. Only one symmetry element is rather neglected, namely mirror symmetry. This is easily understood: since animals have rounded contours, it is impossible to make them fit across a mirror line. If there is mirror symmetry in Escher's drawings, then it runs through the motifs, as in Plates 4, 6, 8, 19, 40. Anti-mirror symmetry is completely absent. Why? Because no animal ever shows it.

Colour symmetry is so essential to Mr. Escher that there are among his designs many more representatives of colour groups than of classical symmetry. In particular, I missed a pattern with nothing but 'plain', i.e. non-colour, twofold rotation symmetry. At my request, Plate 2 was designed especially for the purpose of this monograph. Plate 34 is also new, while several others, e.g. Plate 23, were redrawn for this publication.

The notebook dates from 1942. Thus, in particular the possibilities of the polychromatic groups were explored, and their symmetry elements marked, before official crystallography even thought about them.

Since so much interest is centred nowadays on the colour groups, and since the notion of colour symmetry has been linked up with more formal group theory and its many applications in crystal physics, I have given a fairly large number of representatives of colour groups. With respect to the 'classical' (non-colour) plane groups, Chapter I of the monograph, I have adhered to the notation used in the *International Tables for X-ray Crystallography*, Vol. I (1952). The notation of black-white groups, Chapter II, has not yet been settled by international agreement. However, it appears that Belov's notation is at present mostly used. See W. Holser's introduction to Shubnikov, Belov, et al. (1964). It has the advantage of being easily understood by any one familiar with the notation of the non-colour groups. Chapter III contains six examples of polychromatic groups. I could identify only four of these with cases listed by Belov, et al. (see Shubnikov, Belov, et al., 1964). The polychromatic groups were derived by Belov from those of the 230 space groups in which the equipoints are arranged in equally-spaced layers, by assigning a different colour to each layer. This procedure does not seem to exhaust all the possibilities. I therefore refrained from giving a symbol to the groups in Chapter III and just described their symmetry as well as I could.

In the text accompanying each Plate, the pattern's group symbol is given at the top left hand corner. The meaning of the symbols is briefly explained. With the help of the patterns I have tried to point out the principles of symmetry in diperiodic arrays in a logical order and in a non-mathematical language. Although the book is meant primarily for undergraduate students, I hope that many people who are simply amused and intrigued by Escher's designs will be interested to see how they illustrate the laws of symmetry, and how the trick is done.

Occasionally I have used the designs as an illustration of principles which curiously enough we also find in crystals and their properties.

Although I have avoided the use of professional language as much as possible, a certain minimum of technical terms was necessary. These are collected in an index at the end of the book, referring to the place where they have been first used in the monograph.

Some correspondents have suggested that the patterns be provided with key templates, showing the lattice and the symmetry elements. I think, however, that it will be much more useful and also more fun to the reader if he works this all out himself. In the text I have given as much assistance as I thought might be needed. This may easily be too much in one place, too little in another, and this may vary from person to person. If the reader derives as much pleasure and satisfaction from unraveling the symmetry of these patterns as I did myself, he will feel richly awarded for his efforts.

Artist and author wish to express their thanks to the International Union of Crystallography for its willingness to sponsor this work; to the Commision on Crystallographic Teaching for many helpful suggestions; and to Oosthoek Publishing Company for its interest and care in the preparation of the book.

We are indebted to Dr. N. F. M. Henry for reading the manuscript and correcting the English.

References

M. C. Escher (1960), *Grafiek en Tekeningen* (in Dutch; Tijl N.V., Zwolle).

M. C. Escher (1961), *Graphical Work* (Oldbourne Press, London).

International Tables for X-ray Crystallography, Volume I (1952; Kynoch Press, Birmingham, U.K.).

A. L. Loeb (1971), *Color and Symmetry* (John Wiley & Sons Inc., New York-London-Sydney-Toronto).

A. V. Shubnikov (1951), *Symmetry and Antisymmetry in Finite Figures* (in Russian; USSR Akademiya Nauk, Moscow).

A. V. Shubnikov, N. V. Belov, et al., edited by W. Holser (1964), *Colored Symmetry* (Pergamon Press, Oxford). This book contains a very extensive reference list of the literature on symmetry.

A. V. Shubnikov and V. A. Koptsik (1972), *Symmetry in Science and Art* (in Russian; Izdatel'stvo Nauka, Moskva).

Patterns with Classical Symmetry

Plate I

The two drawings of Plate I can each be generated by repetition in a regular way of a given *motif*, always in the same orientation. This motif is clearly a fish and a boat in pattern Ia, a fish and a frog in Ib. The whole pattern of either figure is then obtained by fitting these motifs as in a jigsaw puzzle. It is seen that the figures could be extended *ad infinitum*, such as to fill completely two-dimensional space. Then each motif is surrounded by all others in exactly the same way. This implies that such an infinite pattern can be brought to coincidence with itself by parallel shifts from one motif to any one of the others. Such a selfcovering parallel shift is called a *translation* of the pattern. In order to explore systematically all possible translations, we choose an arbitrary point in Ia as origin, e.g. the snout of one of the fishes. Cover the figure with a sheet of transparent paper, and mark this point and the equivalent points in all the other motifs of the figure. The collection of points thus obtained is called the *lattice* of the pattern. A vector from the origin to any point of this lattice defines a possible translation of the pattern, and there are no other translations except these. Since the lattice itself is repetitive, it is arbitrary which of its points is chosen as origin.

We now shift the transparent paper covered with lattice points across the underlying pattern. As long as mutual orientation is kept constant, the points of the lattice coincide at each position of the transparent sheet with mutually equivalent points of the motifs. In other words: the lattice is independent of the choice of origin in the pattern.

Choose a vector **a** between two lattice points, such that there are no other points on **a**. All vectors u**a**, where u is an integer, are also lattice vectors. The set of points at distances u**a** is called a *row*. We can collect all the lattice points into a set of parallel, equidistant rows with direction **a**. Now choose a vector **b** from a point in one row to an arbitrary point in a neighbouring row. It is then seen that any translation can be thought to consist of a number u of shifts **a**, followed by a number v of shifts **b**. Symbolically, the lattice can thus be defined by the following equation for an arbitrary lattice vector **t**:

$$\mathbf{t} = u\mathbf{a} + v\mathbf{b},$$

where u and v are integers, varying independently from $-\infty$ to $+\infty$.

The 'basic vectors' **a** and **b** define a parallelogram, called the unit cell, or shortly 'cell'. Now, instead of describing the pattern as obtained by fitting together identical motifs consisting of one boat and one fish, we can define it by the contents of a cell with edges **a** and **b**. The whole pattern can be divided into such parallelograms which are identical in shape and content.

Note that, with given choice of **a**, the basic vector **b** can be chosen in an infinite number of ways, as a vector between two points on adjacent **a**-rows. On the other hand, there is also an infinite number of possibilities for **a**, such that **a** is the shortest distance between two points in a given direction. The parallelogram defined by a pair

3

of these basic vectors is in general different in shape from the first chosen cell but it is identical in magnitude. The total contents of the parallelogram on any pair of basic vectors is therefore always composed of the various parts of one fish and one boat, but cut out and distributed inside the cell in different ways.

When any of these parallelograms is repeated by all the translations of the lattice, the original pattern is, of course, regenerated. It is convenient and conventional to choose the cell in such a way that one of its edges is the shortest translation in the lattice, and the other is the shortest point-to-point distance between two rows defined by the first translation.

Find three sets of basic vectors in Plate 1a, and two in Plate 1b. Trace the contents of the corresponding unit cells, and check that they are all composed of the elements of one motif.

Let \mathbf{a} and \mathbf{b} be two basic vectors. Two lattice vectors are defined as
$$\mathbf{a}' = u_1\mathbf{a} + v_1\mathbf{b}; \quad \mathbf{b}' = u_2\mathbf{a} + v_2\mathbf{b}.$$
Find the condition for the parallelogram on \mathbf{a}' and \mathbf{b}' to be 'primitive', i.e. to contain only one motif in parallel orientation.

4

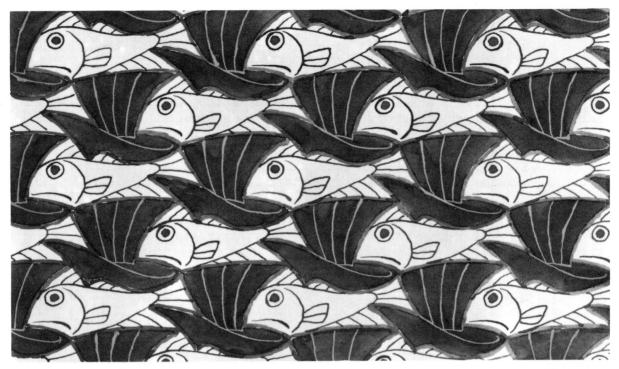

PLATES 1a AND 1b

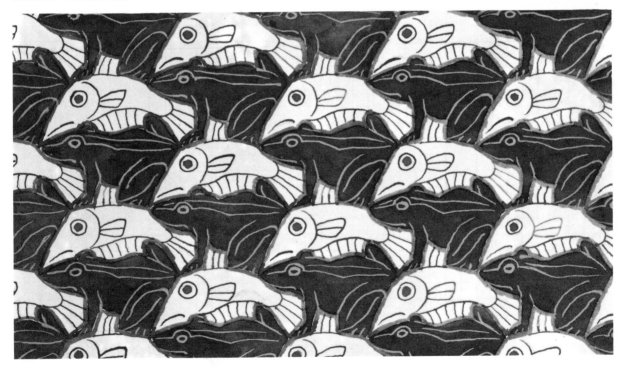

Plate 2

This pattern is more complicated than the former two. It consists again of two different objects, birds and fishes. The birds are all alike, but half of them appear to move upwards, the others move down. Translation, i.e. parallel shift, can bring the birds flying up to coincidence, and also the birds flying down, but it cannot shift an upward moving bird into one of the other set. The same holds, mutatis mutandis, for the fishes. When we plot the lattice according to the instructions given with Plate 1, we must therefore take care to select identical points in identically oriented surroundings, for example, the beaks of all the birds flying up. When we now outline a unit cell, we find that it contains two white birds and two dark fishes. We now ask which operation can bring these two birds to coincidence, together with their surroundings of fishes and other birds. Move the transparent paper with the lattice points across the pattern, until they coincide with the points in the pattern where the right wings of two birds come together. At the same points the right fins of two fishes meet. Now, rotate the pattern in its own plane about one of these points over an angle of 180°. If the pattern had been infinitely extended, it would by this operation have been brought into exact coincidence with its former position. The pattern is said to have twofold rotational symmetry. Rotation through any multiple of 360°/n is referred to as an n-fold rotation.

There are three other sets of translation-equivalent twofold rotation points, namely where (a) the heads of the birds, (b) their tails, (c) their left wings meet. Note the difference in surroundings between the last-mentioned set (set c) and the set of points between the right wings.

Since there are four different sets of twofold points, it follows that there are four non-equivalent twofold points per unit cell. No matter how the basic vectors are chosen, these points always lie at distances of $\frac{1}{2}\mathbf{a}$, $\frac{1}{2}\mathbf{b}$, and $\frac{1}{2}(\mathbf{a}+\mathbf{b})$ respectively.

Check this by making two different choices of \mathbf{a} and \mathbf{b}. Choose as origin of a cell one of the twofold rotation points. Draw the cell and check that it contains two birds and two fishes in non-parallel orientation.

Find an 'asymmetric unit', that is, a part of the figure from which the whole pattern can be generated by both translation *and* twofold rotation. How many asymmetric units are contained in one cell of this pattern?

6

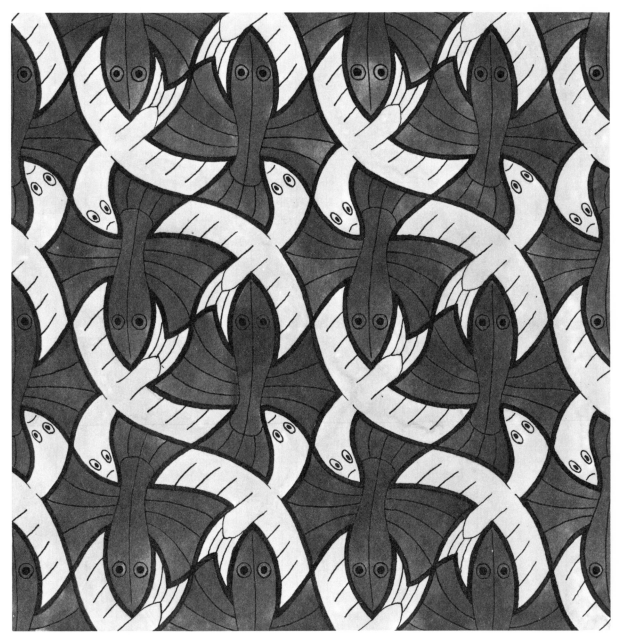

PLATE 2

Plate 3

The pattern is again built up from two figures, a black man and a white man, each occurring in two different orientations. Therefore, the unit cell again contains two black men and two white. Note that in this case it is impossible to bring e.g. the two white men to coincidence by a rotation. This is immediately evident from the fact that the man looking towards the right end of the figure extends his right arm and lifts his left hand, whereas the opposite holds for the man heading towards the left. An operation by which 'left' and 'right' appear to be interchanged is, of course, reflection in a mirror. Since 'up' remains 'up' in this figure, the mirror must be thought to be vertical. However, in the present case the covering operation of the pattern is not a simple reflection across a vertical line, but a reflection coupled with a shift parallel to such a line. This complex symmetry element is called a *glide-reflection line*, or shortly, glide line, abbreviated g. Such a line runs approximately between the calves of black and white men. The shift **p** coupled with the reflection is the vertical component of the distance between equivalent points of a 'right' man and a 'left' one in the next horizontal row. When the glide-reflection line operates first on a right man and then on the generated left man, a new right man appears in exactly the same orientation as the first and shifted from this one over a vertical distance of 2**p**. Since the operation is repeated in principle ad infinitum, this vector 2**p** is a true translation of the pattern: a glide-reflection line generates a translation parallel to itself, the glide component of the operation being one half of the unit translation vector.

We choose this translation as our basic vector **a**. It appears that there is also a translation **b** in horizontal direction, normal to the glide line. This translation repeats the pattern and therefore also the glide-reflection line. Moreover, halfway between two such parallel lines at distances **b**, there is another glide line with different surroundings. If the first set is chosen to run between the calves of the white and black men, the second set runs across the elbows of the white men.

The vectors **a** and **b** subtend a rectangular parallelogram. In the present case, this parallelogram contains just the four different and differently oriented men; it is therefore a true unit cell. There is another possibility for a repetitive pattern with glide reflection lines, namely, that the rectangle subtended on the vectors parallel and normal to the glide lines contains *two* motifs in parallel orientation, at a distance of $\frac{1}{2}(\mathbf{a} + \mathbf{b})$. Although the rectangle is then not the smallest possible parallelogram defining the pattern by repetition, it is conventional and convenient to work with this 'non-primitive', so-called centred, cell.

In our case, as stated above, the rectangle on **a** and **b** is primitive, and is therefore designated as p, the initial of 'primitive'. The symbol **g** for the glide-reflection is added to this symbol, as indicated in the upper left hand corner. The notation of the former two cases is now clear. The patterns 1a and b have a primitive cell and no symmetry at all, indicated by p1. Plate 2 has a primitive cell and twofold rotation points: p2.

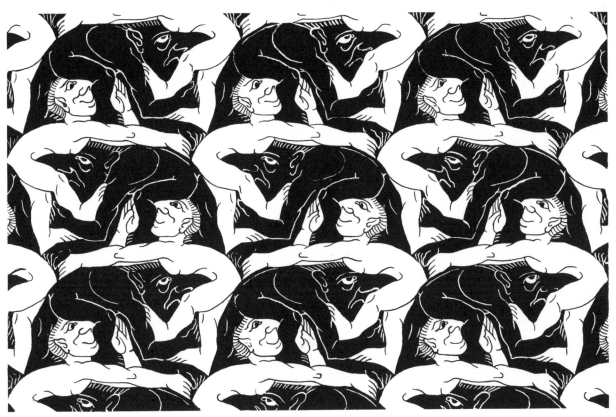

PLATE 3

Draw all the glide lines on a transparent paper covering the pattern. Choose an origin on one of the lines (this is conventionally done). Draw the unit cell. Convince yourself that the cell contains two men of each kind; check that not only is the right black (white) man in itself the exact mirror image of the corresponding left man, but also that their surroundings ad infinitum are each others mirror images.

Choose a simple, asymmetric motif, e.g. a comma, and construct with this motif a pattern with glide lines and a centred rectangular cell. How many glide lines run through this cell? Are there any other symmetry elements?

Plate 4

pmm

The symmetry in this pattern is much more directly evident than that in the former two. It is built up of four kinds of animals, flies, falcons, bats and butterflies, each of which has mirror symmetry. The 'mirror lines' (noted m) through the flies and the falcons run from north west to south east, and the bats and butterflies are reflected by them into their vis-à-vis. On the other hand, the mirror lines running north east to south west bring the bats into coincidence with themselves, likewise the butterflies, but reflect a fly heading south east into one heading north west, vice versa, and the same holds for the falcons.

The presence of two sets of reflection operators intersecting at right angles introduces other symmetry elements: the point of intersection of any two mirror lines is a twofold rotation point.

Since in this case the twofold rotation points follow automatically from the two sets of mirror lines, it is not necessary to mention them in the symmetry symbol.

Outline a unit cell with origin at the tip of the wing of a falcon. Is this cell primitive or centred?

How many mirror lines run through the cell? How many twofold points does it contain? Are these points equivalent in the sense that their surroundings are identical, apart from orientation?

Now shift the origin to one of the rotation points, and again count the symmetry elements. Realize that the number of each kind of symmetry element per cell must be independent of the choice of the origin.

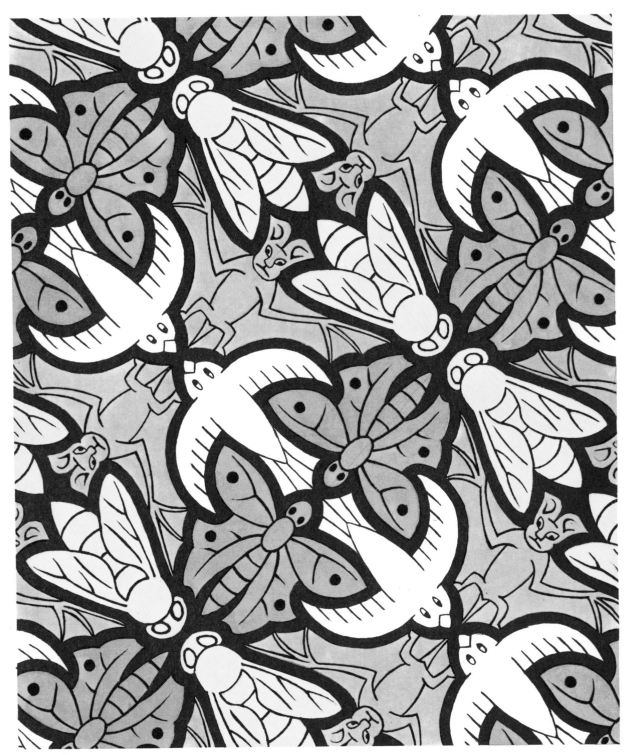

PLATE 4

Plate 5

pgg

The animals in this figure have nearly mirror-symmetry; however, it is clear that the symmetry of the pattern as a whole is quite different from the preceding figure. On closer inspection it is seen that the nearly equal right and left halves of the animals are surrounded in quite different ways by their neighbours. Therefore, the (pseudo-) symmetry of the animals is not a symmetry element of the pattern as a whole. On the other hand, it can be checked that all the dark animals are equal and surrounded similarly, only in different orientation, and the same holds for the light ones.

The most conspicuous symmetry elements in the pattern are the twofold rotation points between the heads of the light animals. It is easiest to choose one of these as origin of the cell. It is seen that there is a twofold point in the centre with equivalent surroundings but different orientation, namely reflected with respect to the one at the origin. It is thus evident that there is glide symmetry. Actually there are two sets of glide lines (notation pgg), both horizontal and vertical, and cutting the edges of the cell at $\frac{1}{4}$ and $\frac{3}{4}$.

Draw the glide lines on transparent paper and mark all twofold points. Note that these are of two different kinds only, compared to four in the preceding figure (pmm). Note that these rotation points lie at the centres of the rectangles outlined by the symmetry lines, instead of at the corners as in Plate 4.

Note that two sets of mutually perpendicular symmetry lines, be they mirror or glide lines, introduce twofold rotation symmetry, whereas this is not the case if only one set is present (Plate 3).

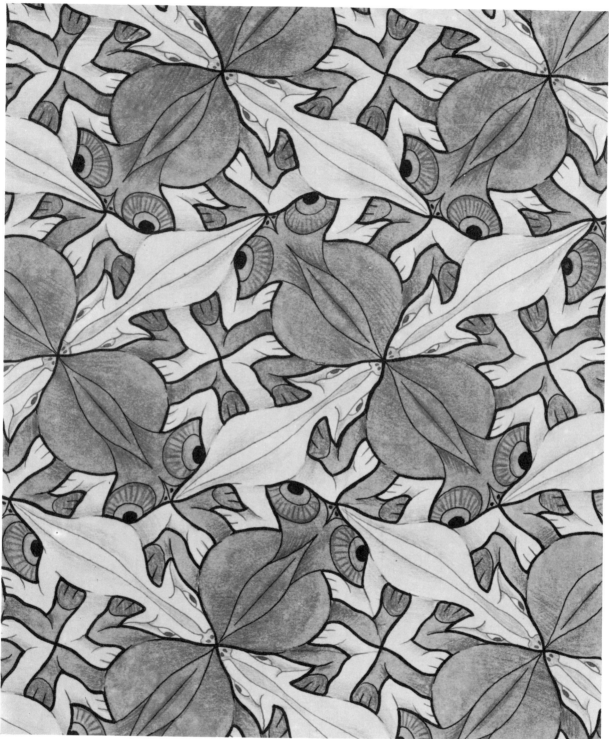

PLATE 5

Plate 6

p4g

The pattern has evidently fourfold rotation and mirror symmetry. In order to classify it properly it is important (as always) to find the unit cell first. It is seen that near the bottom of the picture there is a row of three fourfold rotation points. Of these, only the first and third are equivalent by translation; the surroundings of the three points are alternately 'left' and 'right' since there are mirror lines running between them. Choose the point in the middle of this row as origin and find in the pattern three other fourfold points in the same orientation. These outline a square unit cell which is tilted at $45°$ to the borders of the picture. There is a fourfold point in the centre which is not surrounded in the same orientation as the ones at the corners of the cell. Moreover, halfway between the fourfold points along the axes **a** and **b** there are two-fold rotation points. The total rotation symmetry per unit cell is therefore generated by two fourfold and two twofold points. This combination of rotation operators is present in any plane pattern with fourfold rotation symmetry, whether reflection symmetry is present or not.

In the present picture the orientation about the two fourfold points in the cell can be brought into coincidence by the mirror lines which run parallel to the diagonals of the cell; however, we see that this coincidence is also achieved by glide lines running parallel to the cell edges.

We see that the pattern as it were combines the symmetry pmm of the pattern of Plate 4 and the symmetry pgg of Plate 5, with the glide lines at $45°$ to the mirror lines, such that the twofold points of pmm coincide with half of the twofolds of pgg. It can be shown that this combination gives rise to fourfold symmetry. Alternately: the combination of fourfold rotation points with glide lines parallel to the edges of the cell, running between its corners and its centre, introduces mirror lines through the twofold points parallel to the cell diagonals. Find an 'asymmetric unit' of the structure. How many are there per unit cell?

Try to derive another combination of the system of four- and twofold rotation points described above, with reflection symmetry such that no new rotation points originate.

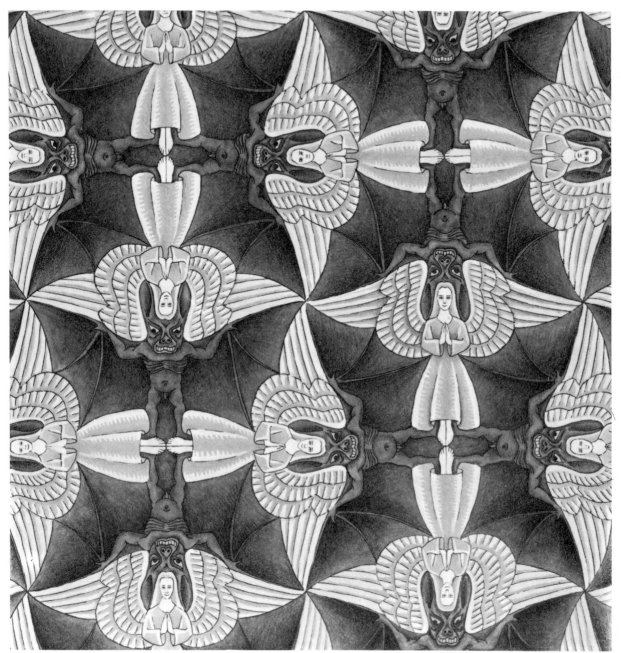

PLATE 6

Plate 7

P3

This pattern is composed of flowers with fivefold rotation symmetry and five mirror lines, superimposed on a bed of asymmetrical leaves. Even when we disregard the leaves, it is seen that the pattern composed by the flowers has no fivefold symmetry. In fact, the centres of the flowers are no symmetry elements of the pattern as a whole. There is, however, threefold symmetry. Threefold rotation points lie on horizontal rows, between the rows of flowers. On such a row, every fourth point is equivalent by translation to the first, so that there are three of these threefolds per unit cell. At first sight, two of these appear to be equivalent by reflection across a vertical line; but this is not really a mirror line, as is seen where it cuts through the third kind of three-fold point on the next row. By marking the translation-equivalent points on all the rows, the translation lattice is found.* As unit cell can be chosen a rhomb with angles of $120°$ and $60°$. This rhomb can arbitrarily be chosen in one of three equivalent orientations differing by $120°$. The three non-equivalent threefold points are at 0, $\frac{1}{3}$ and $\frac{2}{3}$ respectively of the long diagonal of the rhomb. It can be shown that fivefold symmetry in a periodic pattern is impossible, so that any trial to fit a motif with fivefold rotation symmetry in a periodic pattern which conserves this symmetry, is doomed to failure. This does not mean that one cannot build a regular pattern from objects with fivefold symmetry. This is always possible, even with spherical-symmetrical objects, only the symmetry of the object cannot be continued into its surroundings.

Even when an object has in itself a symmetry which could be present in a periodically repeated pattern, then quite often in the packing no use is made of this symmetry. We saw an example of this in Plate 5, where the animals could easily have a mirror line. In the same way, it is rather the exception than the rule when molecules with an intrinsic mirror plane crystallize in such a way that the packing is symmetric with respect to this plane.

* Disregard the change of colour halfway the figure, which is irrelevant for our purpose.

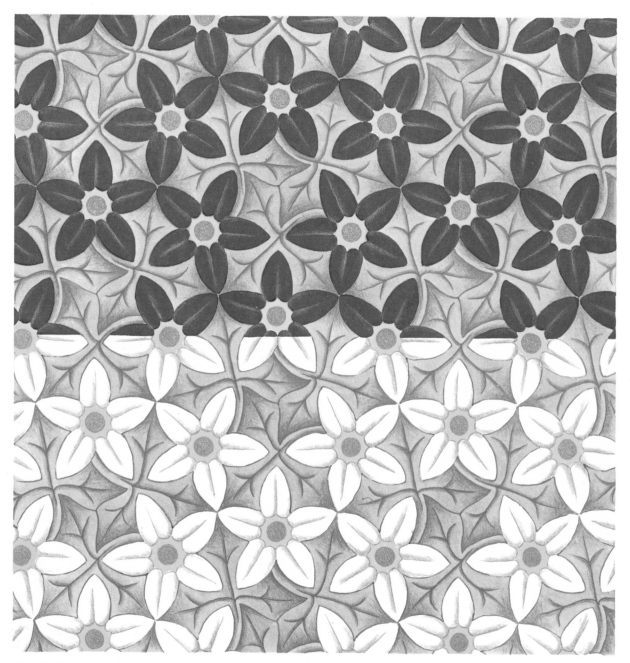

PLATE 7

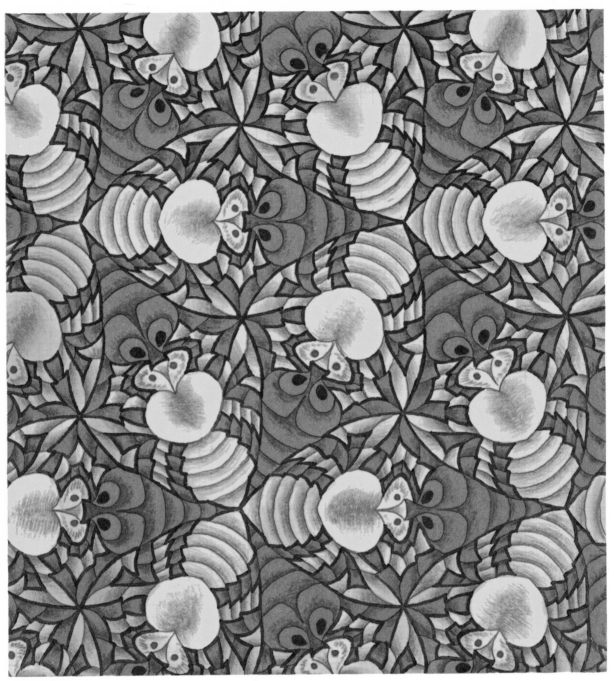

PLATE 8

Plate 8

p3ɪm

The symmetry of this pattern is closely related to the preceding. It is also a pattern with threefold symmetry. Choose as origin one of the threefold points where the abdomens of the insects come together, and find the translation-equivalent points. Inside a unit rhomb there are again two other threefold points, at $\frac{1}{3}$ and $\frac{2}{3}$ of the long diagonal, where the legs of bees and wasps come together; these are now truly symmetry-related, being brought to coincidence by the mirror line along the short diagonal. Mirror lines along the cell edges convert these points into the ones in neighbouring cells. Note that the orientation of the cell edges differs by 30° from that in the preceding figure. This is, of course, immaterial.

Apart from mirror lines there are also three sets of glide lines in this pattern.

Find these. Compare your result with that of the exercise given at the end of the discussion of Plate 3.

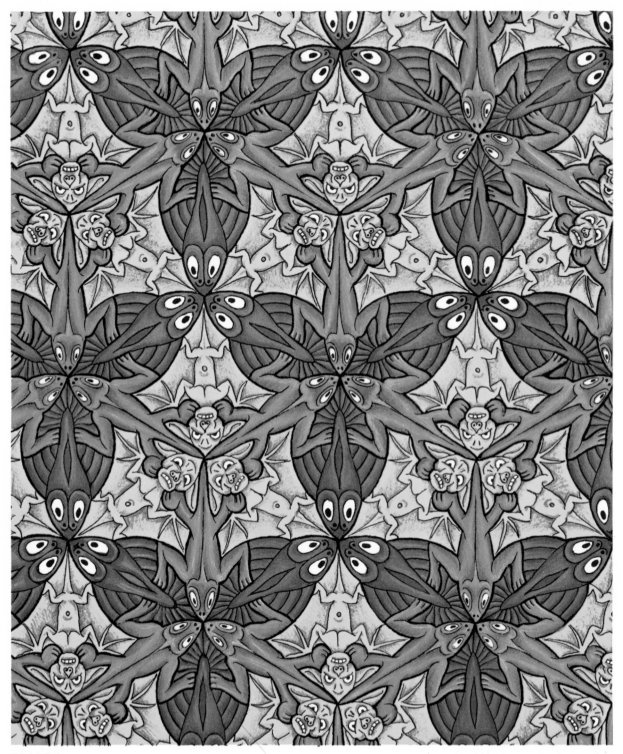

PLATE 9

Plate 9

p3m1

This is another possible combination of threefold rotation points and mirror lines. These run clearly along the long diagonal of the unit cell and the two directions which are equivalent to it by rotational symmetry. Note that now the three rotation points in the cell are all differently surrounded.

Are there any glide lines in this picture?

The notation of the symmetry of this and the preceding pattern differ in that the symbols m and 1 are interchanged. The first symbol after the symbol 3 for the threefold points indicates whether there are symmetry lines *normal to* the cell edges and the equivalent short diagonal. The second symbol refers to symmetry lines normal to the long diagonal and the two directions equivalent by threefold rotation. The symbol 1 means 'no symmetry line normal to this direction'.

Plates 10, 11, 12

The following three patterns provide the reader with an opportunity to test his ability to apply the principles of symmetry set out in the preceding pages.

Plates 10 and 11 are cases very similar to two others treated before. Determine the symmetry in the two patterns and identify it with that of former patterns. Note how the result of a repeating procedure depends on the motif on which it works.

Plate 12 again represents a simple symmetry treated before. The pattern is complicated because the 'motif' on which translation and symmetry operate is very large: the asymmetric unit consists of twelve birds differing in colouring and attitude. The best approach is first to find the unit cell and then to look for possible symmetry. Note that each of the twelve individual birds is surrounded in a different way by the others; although some of them are deceptively similar, it is seen from their neighbours that they are not related by symmetry or translation.

It may be remarked that analogous cases are sometimes met with in crystal chemistry. A crystal may be composed of organic molecules which by chemical standards are all alike, but in the crystal they may fall in two or more sets, each set being in itself related by translation and symmetry, but molecules of different sets being surrounded in different ways. Quite often the molecules themselves are still very similar, notwithstanding their different surroundings. However, cases have been reported where two molecules in the asymmetric unit have distinctly different conformations.

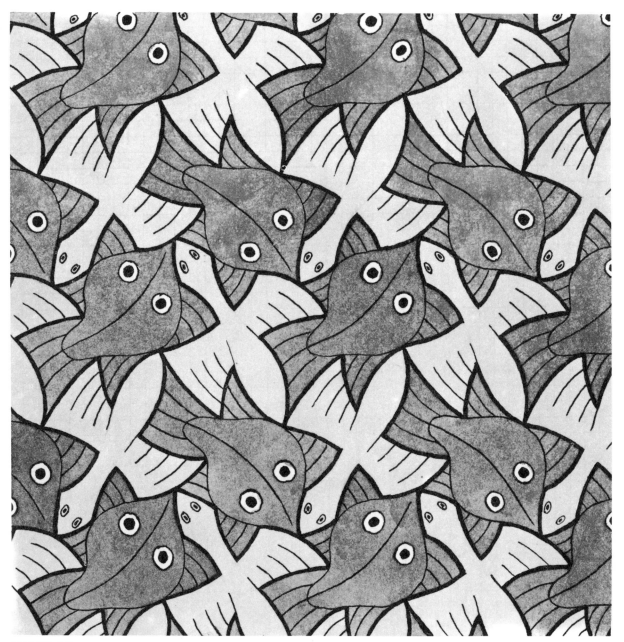

PLATE 10

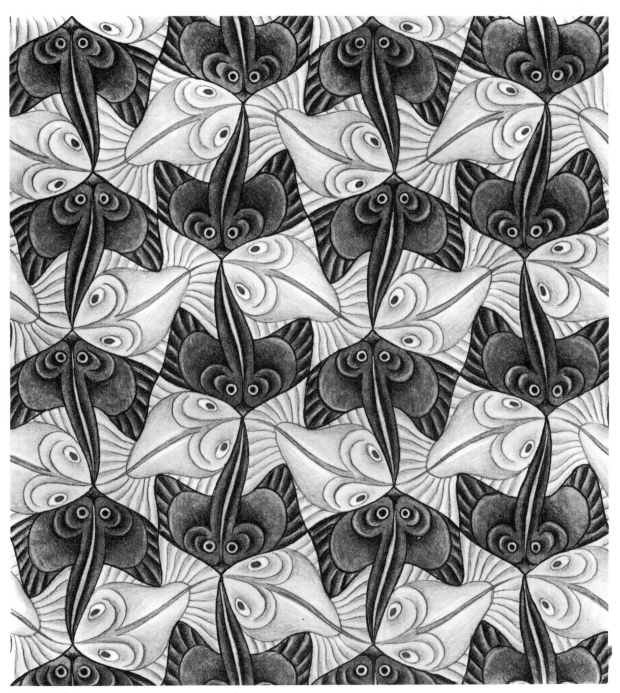

PLATE 11

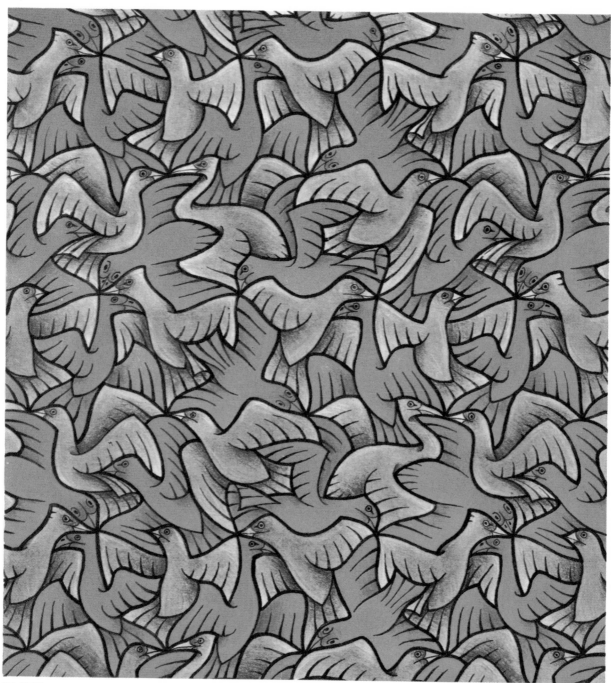

PLATE 12

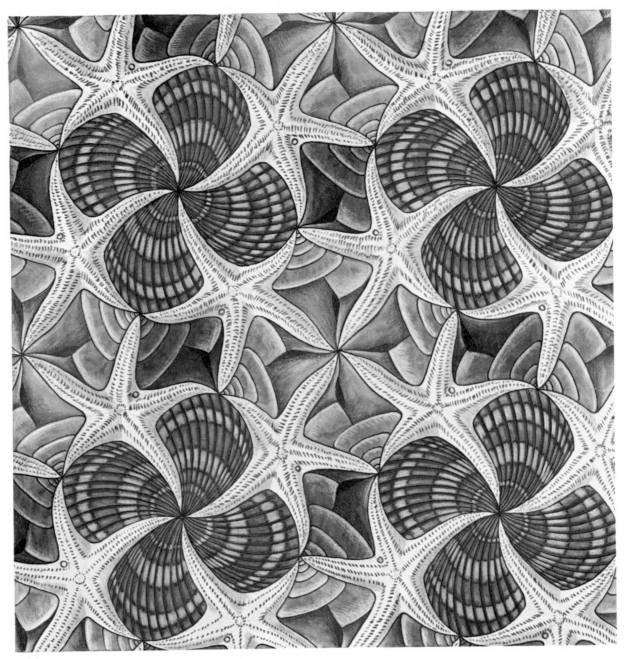

PLATE 13

Plate 13

The pattern presents a tricky problem. It is formed by an array of starfishes, clams and snail shells. At first sight, one would mark as cell corners the points where four clams and four starfishes meet. However, on closer inspection it is seen that the edges of this square are no true translations of the pattern: the snail shells halfway between these pseudocell corners are not repeated in identical orientation by such shifts. Moreover, although the corners of the pseudocell appear to be true fourfold rotation points, it is again seen on closer inspection that they are not. We saw before that there is always a twofold point halfway between two translation-equivalent fourfolds. (This twofold point may be fourfold, which includes a twofold.) Therefore, if the points where four clams meet had fourfold symmetry, then the snail shells halfway between them should have twofold rotation symmetry, and this is evidently not the case.

On the other hand, the mid-point of the pseudo-cell, where four starfishes and four snail shells meet, is indeed a true fourfold rotation point, and so are three other points in the figure. The points where the clams meet are twofold symmetry points, which can be easily checked.

Find the four true fourfold points in the figure. Which of them are equivalent by translation? What is the relation between the edges of the true cell and those of the pseudo-cell?

The question remains whether there is any further symmetry in the pattern. This could only be caused by mirror or glide lines. It is immediately evident that such symmetry is absent. The corrugation on all clam shells spirals in one sense; likewise all the snails are 'of one hand'. It is therefore unnecessary to search for any mirror or glide symmetry. In the same way it is evident that crystals containing only one kind of optical antipodes, say all l molecules, can never have a symmetry plane; and that such a crystal must be the mirror image of a crystal containing the d-molecules, both with respect to atomic arrangement and to physical properties.

In crystal structures, the presence of pseudo-translations is not at all uncommon. As in the present pattern, these lead to a pseudo-cell (sub-cell) which is an integral fraction of the true cell. Quite often during the growth of such a crystal the sub-cells are stacked with faults: if two adjacent subcells erroneously become identical, then the pseudo-translation behaves locally as if it were a true translation. The original true translations then go wrong.

Try to check this from the pattern, by imagining one of the snail shells to be rotated through 180°.

Such stacking faults can occur so often that only the subcell is found in first instance

by physical methods such as X-ray diffraction. As in the pattern, the trickery is discovered because the pseudosymmetry of the subcell would imply a symmetry of the building units (molecules or ions) which from chemical evidence they cannot possess. For example, a nitrate group could be placed on a pseudo-sixfold axis, whereas we know that it can only have trigonal symmetry.

Coming back to Plate 13, we find that it only has fourfold rotation points, and the twofolds that are generated by the fourfolds arranged in a translation lattice. The symmetry symbol is therefore p4.

Patterns with Black-white Symmetry

Plate 14

Comparing Plate 14 with the patterns 1a and 1b, both similarity and difference is found. As in the Plates 1a and 1b, the motif consists of two items, a white winged horse and a black one. However, while in Plate 1 the two items, e.g. boat and fish, were quite different, in the present case the two horses, apart from their colour, are exactly similar, both in contour and in orientation. Also in surroundings: a black Pegasus is surrounded by white and black ones in exactly the same way and in the same orientation as a white horse is surrounded by black and white ones. We could therefore bring the pattern to coincidence with itself by shifting over a distance between a black and a white Pegasus, at the same time changing white to black and vice versa. Obviously, this is a new symmetry operation which is closely related to, but not identical with the one we defined as 'translation'. Both operations would become identical to an observer who could see the contours but would be unable to distinguish between light and dark colour.

Although this seems a rather hypothetical viewpoint, very analogous cases are met with in crystal chemistry and physics. For example, in the cubic structure of potassium chloride, K^+ and Cl^- ions alternate at equal distances along the cell edges. If such a crystal is put in the path of an X-ray beam, then both kinds of atoms scatter the X-rays in practically the same way. Therefore, whereas a chemist readily distinguishes between Cl^- and K^+, to an X-ray beam they 'look' the same. Thus, although the real translation along a cube edge of KCl is from one K^+ to the next K^+, from X-ray scattering one finds half this distance, namely from K^+ to the next Cl^-, and again from Cl^- to K^+. The cross sections of the two ions for neutron scattering are different, so by this technique one does find the proper translation period.

More subtle differences exist in crystals containing atoms with magnetic moments pointing in different directions. X-rays are 'colour blind' to the orientation of the magnetic moments, but neutrons are again sensitive to this phenomenon.

With respect to Plate 14, we define a colour translation as a parallel shift, coupled with a change of colour, which brings the pattern to self-coincidence. In this Chapter, Plates 14 to 35, there are always only two colours. The colours of the original drawings are reproduced here as dark and light, and we will call them symbolically black and white for convenience. In such two-colour patterns, two successive colour translations bring back the unit cells in the original orientation and colour, and are therefore equivalent to an ordinary translation.

In a plane pattern with colour translation it is always possible to choose as basic vectors one which is an ordinary translation vector, and one which implies a colour change. In the pattern 14 one could, for instance, choose the vertical shift from black to nearest white horse as the basic colour vector \mathbf{a}', where the prime indicates a colour shift. The shortest horizontal shift \mathbf{b}' would also be of the colour kind; the parallelogram subtended on these two vectors would contain in total one horse, some parts

being white and some black. However, a parallelogram of the same size is obtained by choosing as edges \mathbf{b}' and a new vector $\mathbf{a} = \mathbf{a}' + \mathbf{b}'$. Since the new vector is the sum of two colour shifts, the original colour is retained over the shift \mathbf{a}. On the other hand, the parallelogram on the vectors $\mathbf{a} = \mathbf{a}' + \mathbf{b}'$ and $\mathbf{b} = \mathbf{a}' - \mathbf{b}'$ would contain two horses, one black and one white, and would be a unit cell in the classical sense, defining a lattice of pure shifts without change of colour, and regarding a black and a white horse as two objects not related by any symmetry operation.

Prove by vector multiplication that the cell on \mathbf{a} and \mathbf{b} is twice that on \mathbf{a} and \mathbf{b}'. Find other sets of basic vectors, (i) both colour translations, (ii) one colour, one non-colour.

In the notation of black-and-white symmetry groups a prime indicates a change of colour. p′ therefore indicates a primitive cell, containing one motif in parallel orientation, disregarding its colour. p′$_b$ means that subsequent cells in the \mathbf{b}-direction are related by a colour shift so that white parts in one cell are black in the next, vice versa. To this symbol is added '1' to show that the rotation symmetry is 'one-fold': coincidence is only obtained after rotation of 360°.

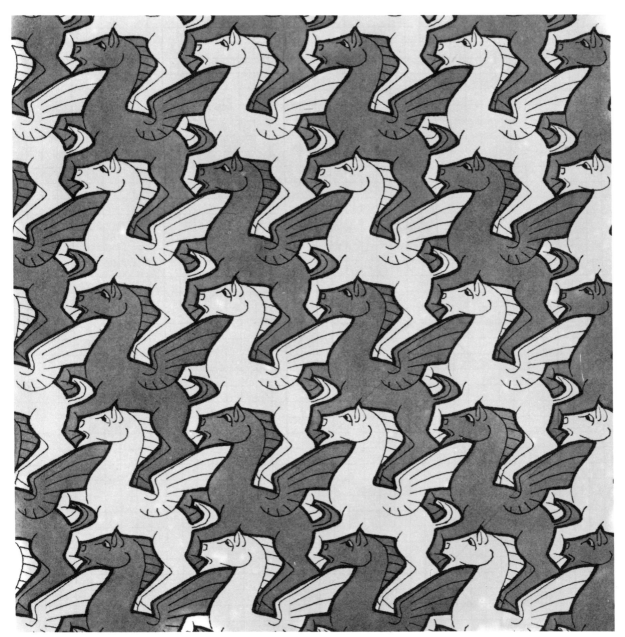

PLATE 14

Plate 15

Like the former, this pattern consists of identical animals, dark and light. However, these are not in the same orientation, the dark fish swimming to the right, the light ones towards the left. It would then seem that they are related by a glide operation, as for instance the manikins in Plate 3, but closer inspection shows that this is not the case.

White and black fishes change place by a rotation of 180° about e.g. a point between the left eyes of a dark and a light fish. The operation can therefore be described as a twofold colour rotation, symbol 2$'$.

Since no black fish is in the same orientation as any white one, translations are all of the ordinary, non-colour type. The lattice is primitive, the unit parallelogram contains one dark and one light fish related by twofold colour rotation. As in the analogous non-colour case p2 (Plate 2), there are four non-equivalent twofold points in the cell.

Find these, and express their mutual distances in the cell edges **a** and **b**.

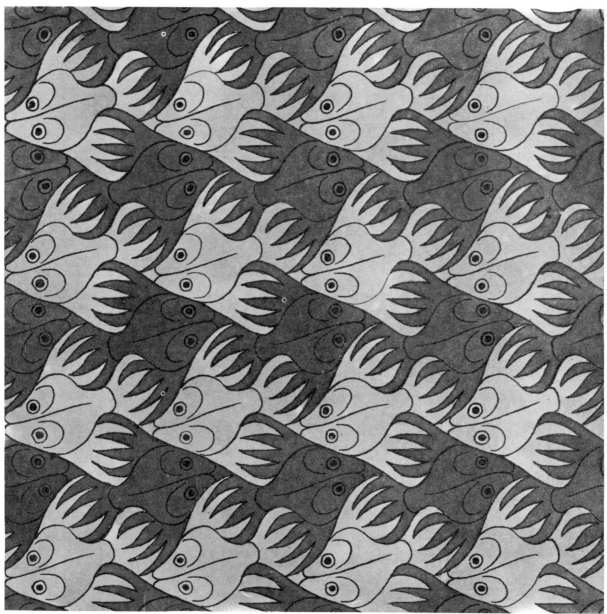

PLATE I5

Plate 16

The pattern combines the operations of the two preceding ones. The shortest translation, running in the direction from the middle of the lower edge of the figure towards the left top corner, is evidently a colour one. – It is conventional, but immaterial, to choose the **b**-axis in the direction of the colour translation.– A second basic vector, from one **b**′ row to the next row of figures in parallel orientation, can always be chosen as a non-colour translation. The colour unit then contains two lizards, partly black and partly white, which coincide by a colour rotation of $180°$. Rows of such colour twofolds run parallel to the (non-colour) **a**-axis: they lie between the heads and the tails of black and white lizards. The rows of colour rotation points alternate with rows of ordinary twofolds. The presence of the latter is easily explained. A twofold point repeated by translation generates a second set of twofold points. If the first twofold changes the colour, and the translation does so too, then the original colour is restored. Conversely, a plain twofold point multiplied by a colour translation gives rise to a new set of twofold colour points alternating with the first set. Therefore, in the notation given above it is sufficient to indicate the colour translation and a twofold rotation, because these two generate the colour rotation.

Find the four different kinds of twofold points. Outline a 'colour' cell and an ordinary cell. Note that the symmetry of the latter, in which white and black figures are considered as different things, is the same as in the pattern of Plate 2.

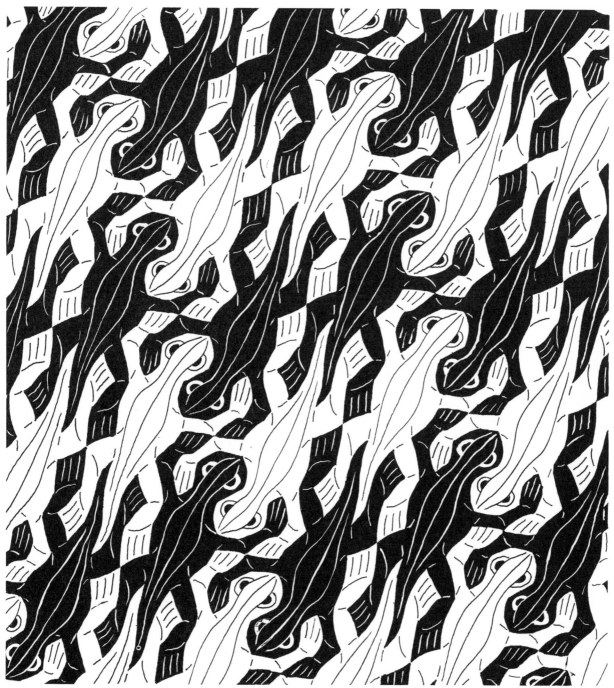

PLATE 16

Plate 17

pg$'$

This pattern has acquired some fame in the world of science. It figured as front plate in a book on the derivation of crystal symmetries, and served as dust cover to a book on elementary particles.

At first sight, the pattern seems related to the fishes of Plate 15: here also there are horizontal rows of figures heading right, alternating with rows of figures heading left However, whereas fishes can still swim when rotated in their own plane through 180°, our horsemen certainly could no longer ride when submitted to this operation. Instead of by rotation, the black horsemen are transformed into white ones, vice versa, by a vertical colour glide operation. We realize gradually that all the operations we met in the first chapter of this book can one by one be coupled with a colour change and thus give rise to new possibilities.

Define a unit cell with horizontal and vertical edges, and draw the glide lines. As in the plain case pg, Plate 3, two glide lines run through each cell, both being of the colour kind. These two glide lines are not surrounded in the same way.

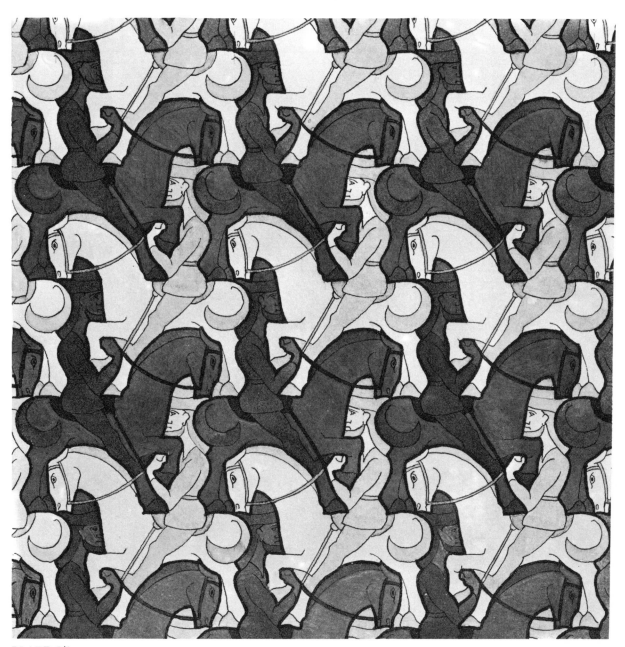

PLATE 17

Plate 18

A horizontal colour translation (**b**-axis) is combined with glide lines normal to this axis. The colour translation **b**′ repeats the glide lines and, as in the pattern of Plate 3, introduces new glide lines halfway between those of the first set. Since the new glide lines are generated by a plain glide, which leaves colour unchanged, and a colour translation, the new set of glide lines is of the colour kind: they run just behind the dogs' front paws, whereas the plain glide lines run between the hind paws of dogs of the same colour.

Note the ingenious way in which the toes of the black dogs 'act' as teeth to the white dogs. By analogy to the convention mentioned with respect to Plate 9, the symmetry symbol indicates that there is no symmetry line normal to the **a**-axis (symbol '1'), and glide lines (g) normal to the colour translation **b**′.

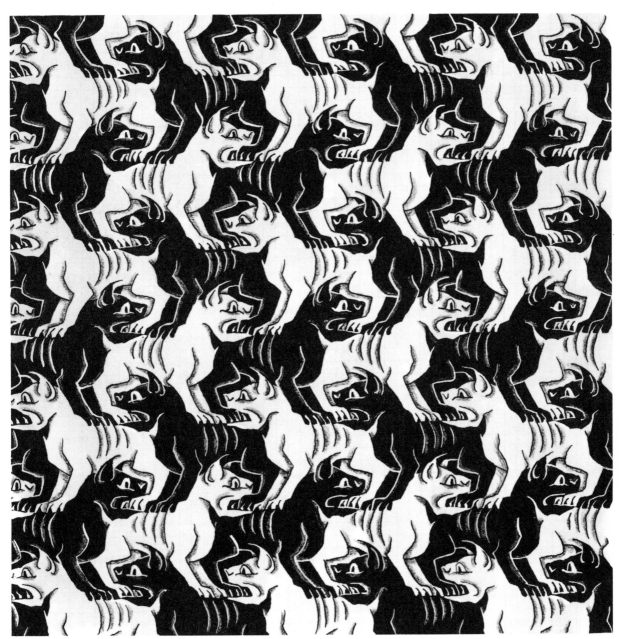

PLATE 18

Plate 19

p$'_c$m

The natural mirror symmetry of the beetles is used as mirror symmetry of the whole pattern. The mirror lines, running vertically from top to bottom, transform all white beetles into white ones and black beetles into black. It is clear though, that black and white beetles are identical and identically surrounded, apart from colour difference. The operation by which black beetles are transformed into white ones, vice versa, is again a colour glide line, parallel to, and halfway between, two adjacent plain mirror lines. We remarked (Plate 3) that it is customary in the case of mirror or glide lines, to choose one cell edge parallel to the symmetry lines, and the other normal to them. If we outline a cell in this way, we see that it contains in total one white and one black beetle. Note that these two are related by a colour translation over half a diagonal of the cell. Therefore, apart from the change of colour, the pattern presents the case of a 'centred' cell, the construction of which was given as a problem in the discussion of the pattern of Plate 3. The presence of a colour translation is indicated by the prime to the lattice symbol p, while the subscript c indicates that this colour translation is over half the diagonal of the rectangular cell.

This colour translation was described above as generated by a mirror line, and parallel to this a glide line. One can also start with either the combination of mirror line and colour translation at an oblique angle, or the combination of colour glide line plus oblique colour translation. Note again that in two-colour symmetry, the original colour is restored after an even number of colour operations, and changed after an odd number, no matter how many plain operations take part.

42

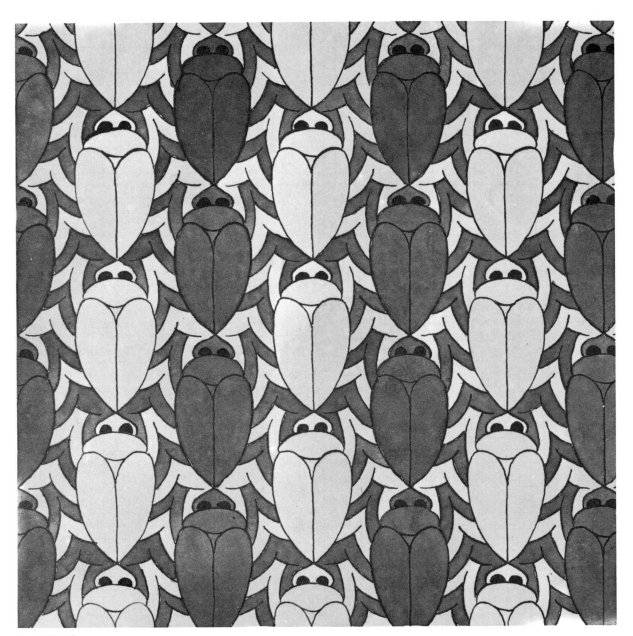

PLATE 19

Plate 20

pmg'

The next four patterns give examples of combinations of two mutually orthogonal sets of symmetry lines, one or both of the colour kind. Moreover, the symmetry lines can be either mirror or glide lines. As in the analogous cases with only plain symmetry (Plates 4 and 5), these combinations generate twofold rotation points. If the two sets of symmetry lines are either both coloured or both plain, the twofold rotations do not involve colour change. If one of the symmetry lines is plain, the other coloured, then the twofold rotation points are 'coloured'.

One of the latter cases is presented in the pattern of Plate 20. The fishes possess mirror symmetry and they fit together so that this symmetry extends throughout the pattern. Black and white fishes are converted into each other by the operation of colour glide lines normal to the mirror lines, c.q. by colour-twofold points lying on the glide lines, halfway between the mirror lines. It is interesting to compare the pattern with Plate 15, which shows essentially the same fishes as those in the upper part of Plate 20.

How many non-equivalent sets of twofold points are there in each of these patterns?

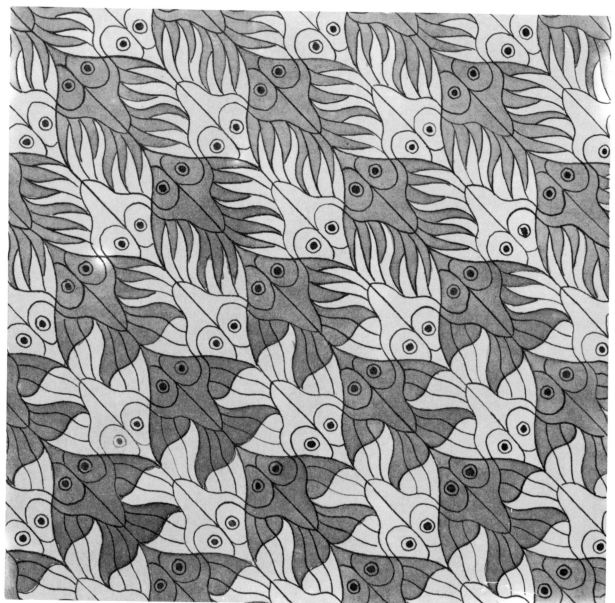

PLATE 20

Plate 21

pg′g

The pattern is somewhat complicated because the unit which is repeated by the symmetry operations consists of two fishes with different attitudes, for example, the light and the dark fish in the upper right hand corner. As Mr. Escher has marked the twofold rotation points, it is easily seen how these points generate horizontal rows of fishes. Note that the twofold points are all of the colour kind. The first and the third row of fishes are equivalent by translation. Subsequent horizontal rows are clearly also equivalent by symmetry, but not by translation. They are connected e.g. by a set of horizontal colour glide lines, the traces of which are still just visible in the drawing. The combination of these colour glide lines with the coloured twofold points must lead to a second set of symmetry lines, orthogonal to the first, and of the 'plain' kind. If the twofolds had been situated *on* the colour glide lines, this would have led to the same case as in Plate 20, and the new set would consist of mirror lines. However, we see that in the present pattern the rotation points lie halfway between the horizontal glide lines. This gives vertical glide lines between the vertical rows of symmetry points. In this respect the situation is the same as in Plate 5.

Construct the unit cell, choosing one of the symmetry points as origin, and count the number of symmetry points and of each set of symmetry lines in the cell. Check that there is no colour translation. How many fishes are there in one cell? How many in a rectangle with adjacent twofold points at the corners?

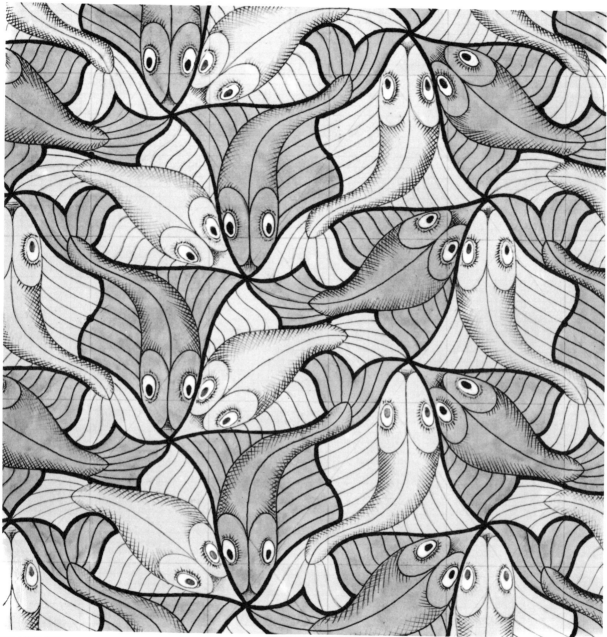

PLATE 21

Plate 22

pg'g'

The most conspicuous symmetry elements in this picture are twofold rotation points, between the heads of the black and the white beetles respectively. By outlining the unit cell, it is evident that there must be two other sets of twofold points. Find these.

None of the twofolds involves a colour change. Since the dark and the light beetles are clearly similar in shape and surroundings, there must be further symmetry elements, of the colour type, which transform them into each other. This is carried out by two mutually orthogonal sets of glide lines. The symmetry is therefore related to that of the previous pattern; only the colour characters of the twofold points and one set of glide lines are interchanged.

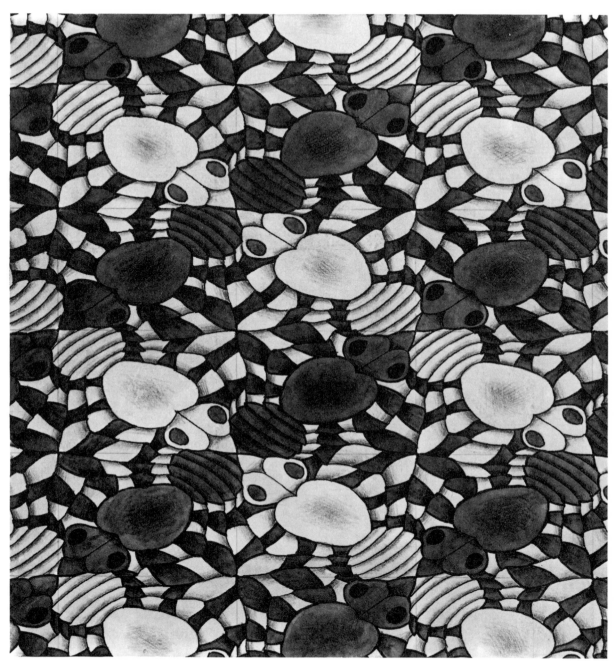

PLATE 22

Plate 23

p$'_b$mg

The colour translation indicated in the symbol runs vertically. The corresponding unit cell edge is conventionally called **b**′. Parallel to this edge is a set of ordinary mirror lines. Furthermore, there is a set of horizontal glide lines. Since these are repeated by the vertical colour translation, they must be alternately of the plain and of the colour kind. The order of m and g in the symbol again indicates that m is normal to the horizontal **a**-axis, and g normal to **b**. It is not necessary to indicate the colour glide lines as such, because they are generated by the colour translation between two subsequent plain glide lines.

There must be twofold rotation points; find them and state whether they are 'colour' or 'plain'. Compare the result with Plate 20.

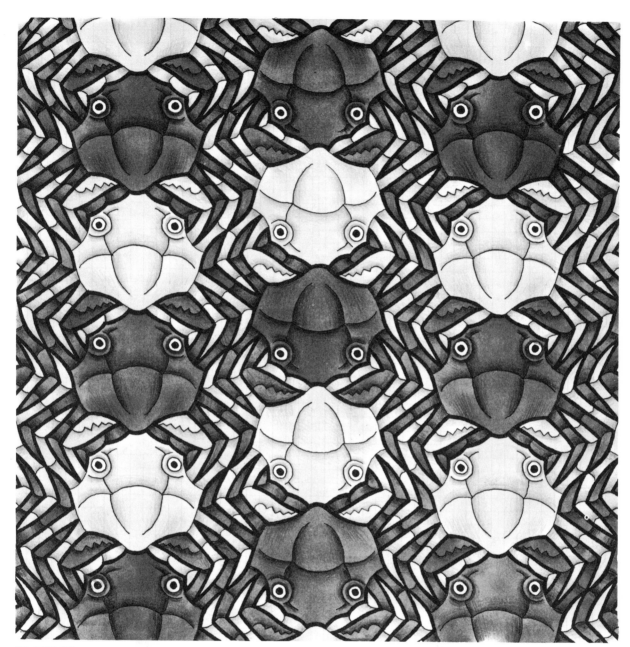

PLATE 23

Plate 24

p4$'$

This is one of Escher's earlier patterns reproduced in this monograph. When we first concentrate on the arrangement of the white lizards, we see twofold rotation points between their lower jaws, their right knees, their left feet and their right front paws. Considering now the black lizards, we see that these same points are located between their right knees, lower jaws, left feet, and right front paws respectively. In other words, the latter two sets of twofold rotation points are also points of rotation of 90° coupled with change of light to dark, vice versa. This operation converts the horizontal white lizards into the black ones crawling up and down. If the operation is repeated, the pattern is rotated in total through $2 \times 90° = 180°$, while the colour has changed from white to black, and black to white again.

Mark all the 4$'$ points and note that they are not all symmetry-equivalent but fall in two sets, as said above. Check that fourfold and twofold points are arranged exactly as those in Plate 13. The difference is that the pattern of that plate has only plain symmetry.

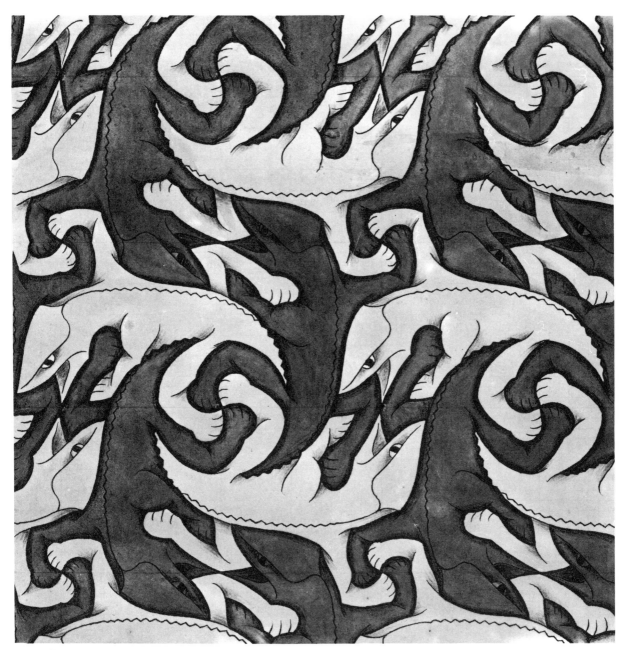

PLATE 24

Plate 25

p'_c4

The symmetry is again fourfold. Ordinary fourfold points are spotted easily where the heads of four white lizards meet, and others where four white tails come together. However, at the latter points four heads of black lizards also meet, whose tails point to the first set of fourfolds. Apart from a change of colour, these two sets of plain fourfolds are translation-equivalent, symbol p'. The obligatory twofold rotation points halfway between two subsequent p'-equivalent fourfolds must also change the colour, as in Plate 16. You will find these 2' points between the left front of each black and its neighbour white lizard. Moreover, there are 4' points where the right elbows of two black and two white lizards meet.

A 'colour-blind' person would choose as cell edges the vectors from head to tail tip of two lizards at an angle of 90°. This cell contains in total four lizards. On the other hand, a colour-conscious person would mark as cell corners for instance the points where four white heads meet. The edges of the colour-blind cell are colour translations which center the cell of the colour-conscious person. Therefore, the same lattice symbol p'_c is chosen as in the case of Plate 19. Further, it is only necessary to indicate the presence of ordinary fourfolds by their symbol 4; all other rotation points then follow automatically. Note again that the 4' points act as plain twofolds when the attention is focused on animals of one colour only.

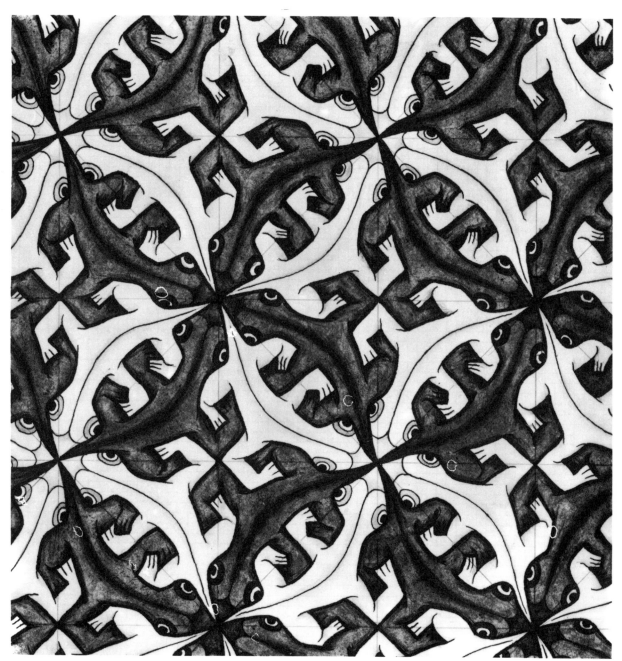

PLATE 25

Plate 26

p4′g

We recognise the insects that stood model for Plate 22, and in their arrangement the symmetry elements of that pattern are found again. However, Plate 26 has evidently more symmetry. Here, the insects have preserved their natural mirror symmetry: their mirror lines are lines of symmetry of the whole pattern. They include angles of 45° with the glide lines that also were present in the pattern of Plate 22.

Now, we saw in Plate 6 that a combination of two orthogonal sets of mirror lines, with two sets of glide lines at angles of 45° to the mirror lines leads to fourfold rotation symmetry. Since the mirror lines are plain, but the glide lines involve a colour change, a rotation of 90° about the fourfold points must also lead to change of colour. Again, as in Plate 24, a rotation of two times 90° then brings back the original colour, and the additional twofold points are therefore also of the 'non-colour' sort. The latter are easier to find than the fourfolds. Therefore it is best to mark the twofolds first. As the pattern also contains the symmetry elements of Plate 4, we must find these points in analogous positions, viz. at the intersection of the mirror lines. It is then easy to find the fourfold rotation points.

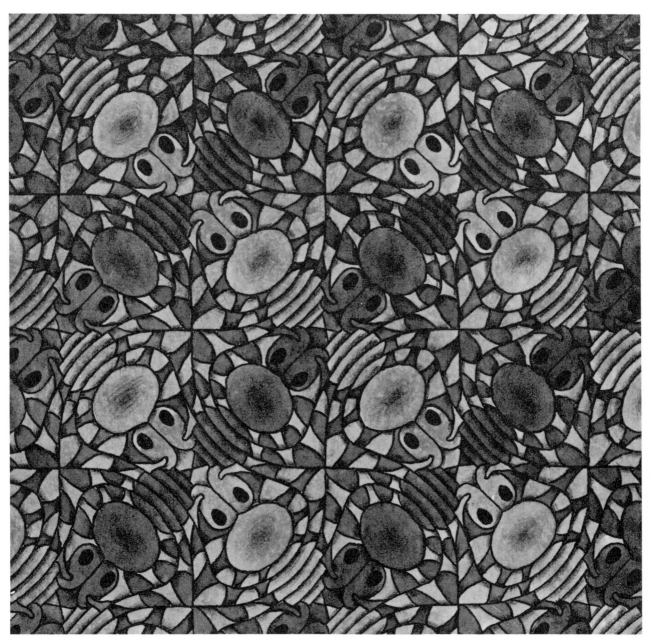

PLATE 26

Plate 27

p6′

The pattern shows horizontal rows of three-fold non-colour rotation points. Consider for example the top row of these points. It is seen that the first two from the left are surrounded in the same way, apart from a rotation of 180° coupled with a colour change. The twofold rotation point is halfway between the two threefolds. The third point of the row is of a different surrounding altogether. There are four of these points in the pattern, all showing the same orientation and thus connected by translation. We can therefore take them as the corners of the unit cell. On closer inspection it is seen that their symmetry is higher than just threefold: they are sixfold rotation points, with a colour change for all odd orders of rotation through 60°.

Among the examples of plain symmetry in this monograph, Plates 1–13, we have not come across sixfold symmetry. It can be proved, and is moreover easily found by trial, that the combination of a sixfold rotation and a translation generates a two-dimensional array of sixfold points at the corners of equilateral triangles. The unit cell, a rhomb with angles of 120° and 60°, contains two of these triangles, just as in the case of threefold symmetry, see Plates 7, 8 and 9.

Since a rotation of 60° repeated three times gives a twofold rotation, there must be twofold points between each pair of subsequent sixfold axes, that is, halfway along the edges of the triangles. In the present pattern, the twofolds are generated by translation of sixfolds which introduce a colour change after rotation through $3 \times 60°$; therefore these twofolds also involve a colour change, as was already found above.

On the other hand, rotation through 120° or 240° does not change colour in the pattern. In fact, a ternary point in a two-colour pattern can never be anything but an ordinary rotation point. If it did change the colour from black to white after rotation through 120°, then a rotation of 240° would restore the original colour, and rotation through $3 \times 120° = 360°$ would again lead to white. Then the original object would be both black and white, that is, gray, and all the symmetry-equivalent objects would have the same colour, which is in contradiction to the original assumption. Since a sixfold point is also a threefold, this means that in a two-colour pattern with sixfold symmetry a colour change can only occur after an odd number of rotations of 60°. The symmetry is thus fully described by the symbol p for a primitive cell and the symbol 6′ for the sixfold black-white rotation.

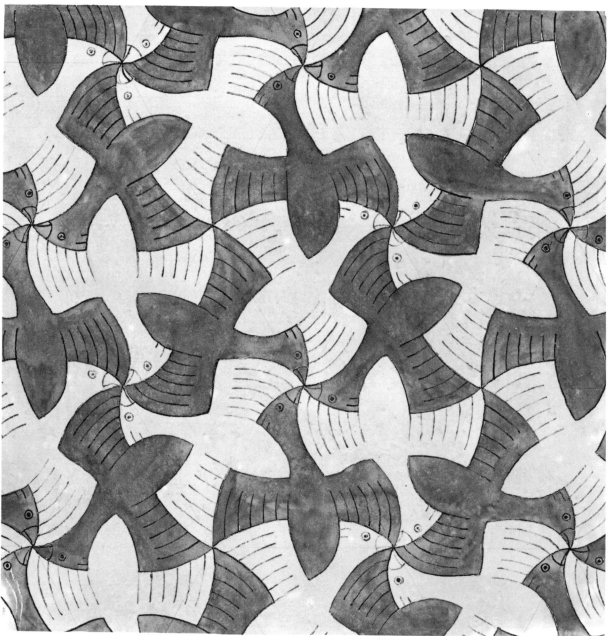

PLATE 27

Plate 28

This pattern was once used as the cover picture of a journal of popularized science. It was described in the text as presenting the case of glide symmetry, presumably a back-white glide transforming white birds into dark ones, and vice versa.

Trace a white bird and check that it is not the same shape as any black one. Therefore, black and white birds are not equivalent by symmetry. Trace a cell, find its contents and give the symmetry symbol of the pattern.

Readers familiar with Escher's art will recognize that this pattern of birds was used in his well-known woodcut called *Day and Night*.

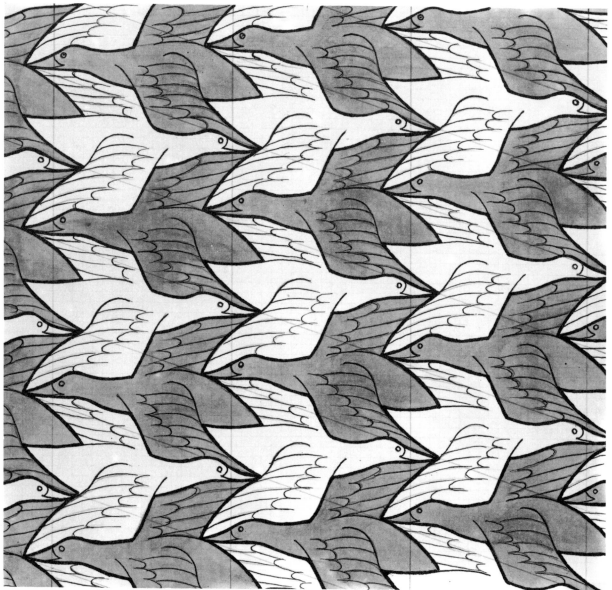

PLATE 28

Plate 29

This pattern was included in the monograph because it gives an insight into Mr. Escher's methods.

On the left the pattern is composed of ferocious-looking fishes, on the right of more sweet-tempered birds. The outlines of bird and of fish are exactly the same, as shown below in the picture, so they fit in the same way, according to the simple rules of p_b' (Plate 14).

From left to right, there is a gradual change from fish to bird, first the black ones, then the white. Therefore, in the middle the pattern consists of white fishes heading left, and black birds flying towards the right. Here the pattern is analogous to Plate 1, there is only ordinary translation.

An analogy can be seen with mixed crystal formation. A general condition for this process is that the particles, ions, atoms or molecules, which replace each other in the structure, should have similar shape and dimensions, although the crystal does not adhere to this principle with the same strictness as the animals in Escher's drawing. The pattern can also be used as illustrating interdiffusion of atoms in two adjoining crystals which have the same or nearly the same lattice dimensions and way of packing.

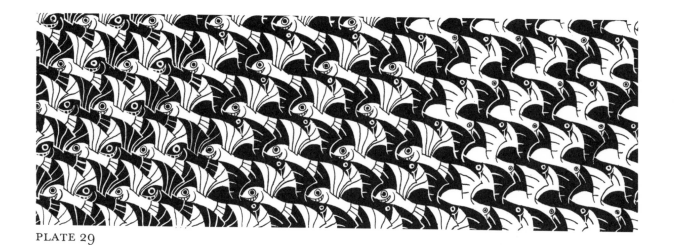

PLATE 29

Plates 30-35

The next six patterns provide some material for exercise. They present symmetry combinations which were treated before. The first three should not give any difficulty. 33, 34 and 35 are a little more tricky. In 33 and 34 it is best to establish first the system of symmetry lines. The position and character of the symmetry points, if present, then follows automatically. As always, it also helps to outline a unit cell.

In Plate 35 twofold points are fairly conspicuous. It is also seen that black and white lizards are equivalent by colour symmetry.

Find the elements by which black and white ones are interconverted.

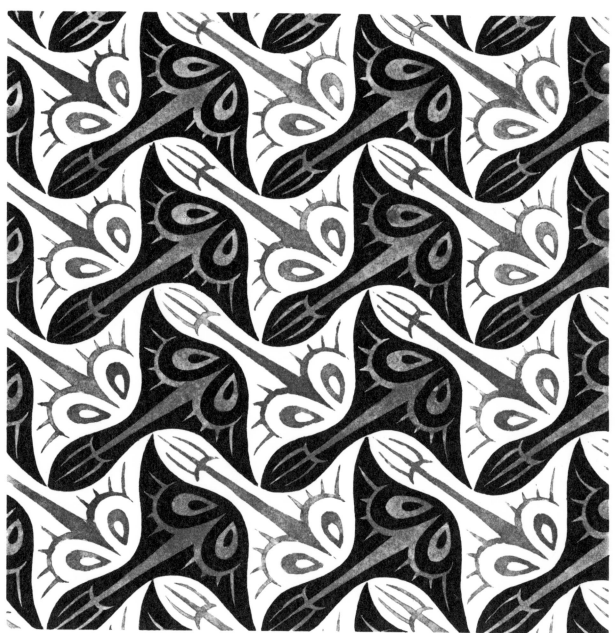

PLATE 30

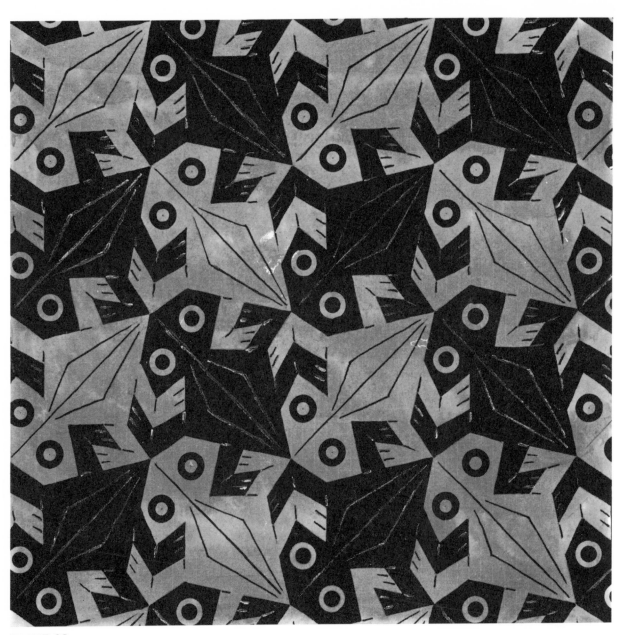

PLATE 31

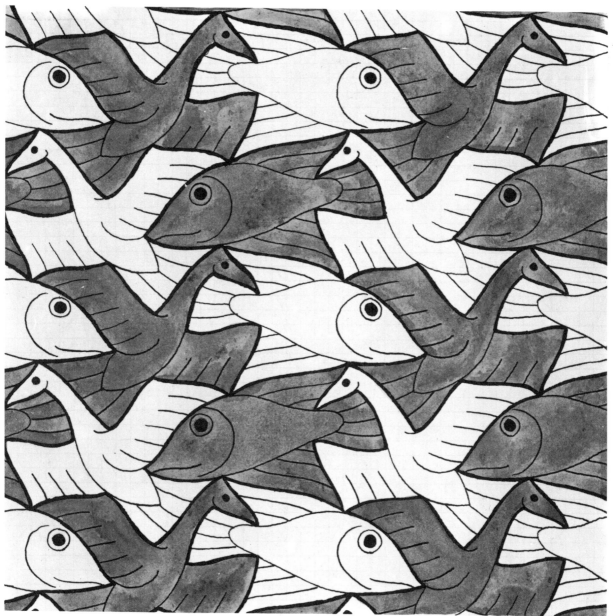

PLATE 32

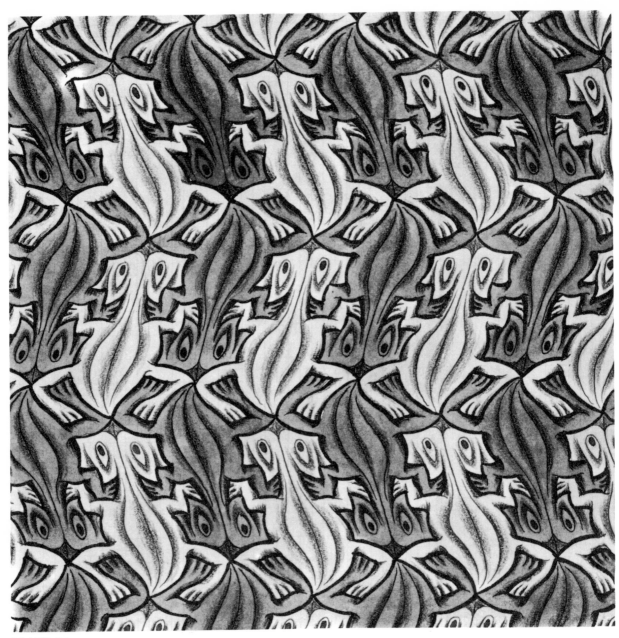

PLATE 33

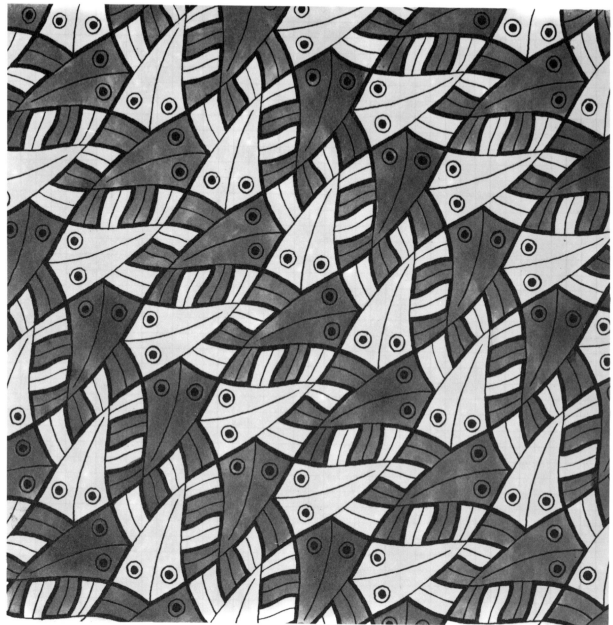

PLATE 34

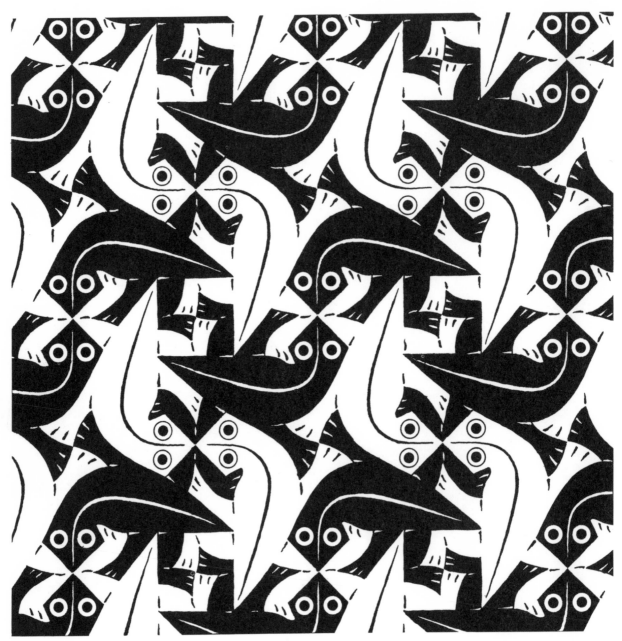

PLATE 35

Patterns with Polychromatic Symmetry

Plate 36

Among the two-colour groups of Chapter II, there were several in which translation was coupled with interchange of black and white. In Plate 36 we see vertical rows of unicorns, all identical in shape, orientation and surroundings, apart from their colour which changes, from top to bottom, always in the order . . . yellow, green, red, yellow, etc. Unicorns in neighbouring rows are not in the same orientation; they are connected by vertical glide symmetry lines which transform a yellow unicorn looking right into a yellow one heading left. As always, by repeating this plain glide operation we obtain the plain vertical translation from yellow to yellow, red to red, etc. However, these same vertical glide lines act as colour symmetry elements, namely, transforming the animals left-right-left, etc. from top to bottom in the colour order yellow-red-green-yellow. Note how this operation generates the colour translation with the opposite sequence of colours, and that the vertical glide component coupled with colour change is one third of the plain glide.

Outline a colour cell and mark the glide lines. Compare the result with those of Plates 3 and 18. In the last-mentioned pattern, black-white glide lines alternate with plain glide lines. In Plate 36, which also combines a colour glide with one plain and one colour translation, all the glide lines are of the same colour type. What is the reason for this difference in behaviour?

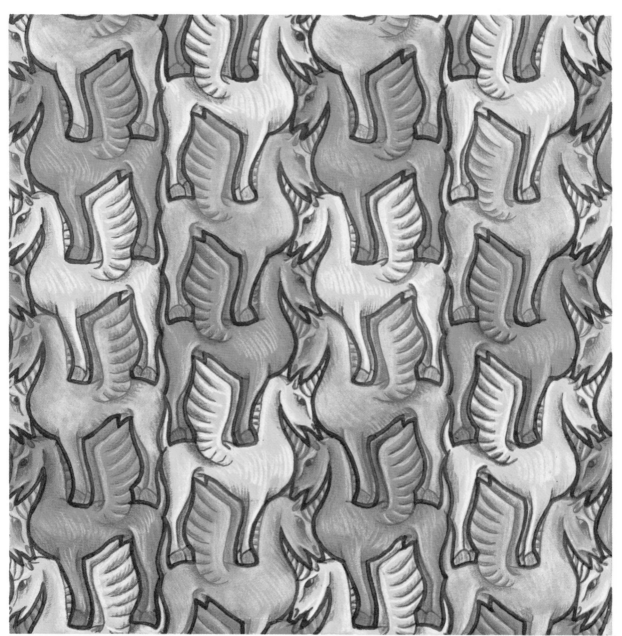

PLATE 36

Plate 37

This is a more typical case of colour symmetry.

The pattern is composed of fishes in four different colours and orientations. All the fishes of one colour have the same orientation and surroundings, so there is one fish of each colour per cell. Since they are of identical shape and surroundings, and since there is a 90° difference in orientation between the pairs brown-red, red-blue, blue-white, and white-brown, there must be fourfold colour-rotation points. These are easily found in the pattern. There are two of them per cell, with the same colour permutation order but with different surroundings. In this respect, the situation is the same as in Plate 24. Again, there must be twofold rotation points halfway along the cell edges, if we choose the origin on one of the fourfolds. Since a rotation of two times 90° now does not restore the original colour, as was the case in Plate 24, these twofolds also include colour changes, namely from red to white, from blue to brown, and vice versa.

Check that this is the case for each rotation through 180°.

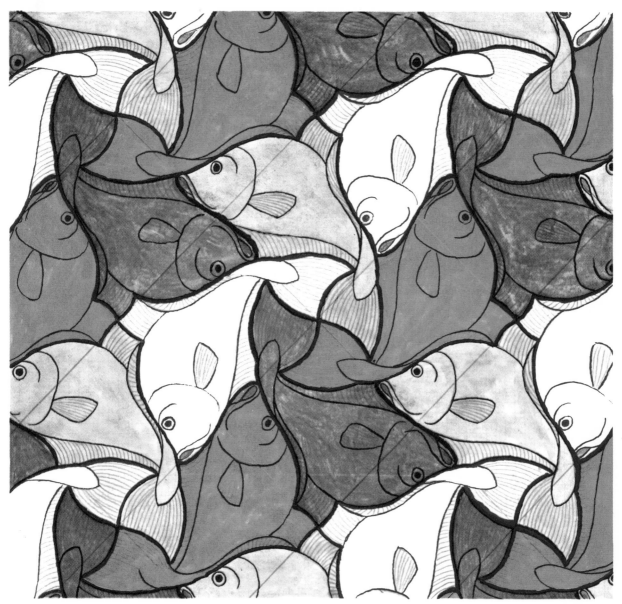

PLATE 37

Plate 38

The pattern shows the simplest possible case of threefold colour rotation symmetry. A symmetry point between the heads of three differently coloured lizards is probably spotted first. From here the cell is easily traced, as all lizards of one colour are in the same orientation. As with plain threefold symmetry (Plates 7, 8, 9) the cell is a rhomb with angles of 120° and 60°, containing in total three threefolds along the long diagonal. Since in the present case there is no other symmetry, these three are all different in surroundings.

Check that they have the same scheme of colour change.

Whereas a threefold rotation cannot be coupled with an interchange of two colours, as stated in the discussion of Plate 27, we see here that an interchange of three colours is possible, since it brings back a motif in the original colour after a rotation of $3 \times 120° = 360°$.

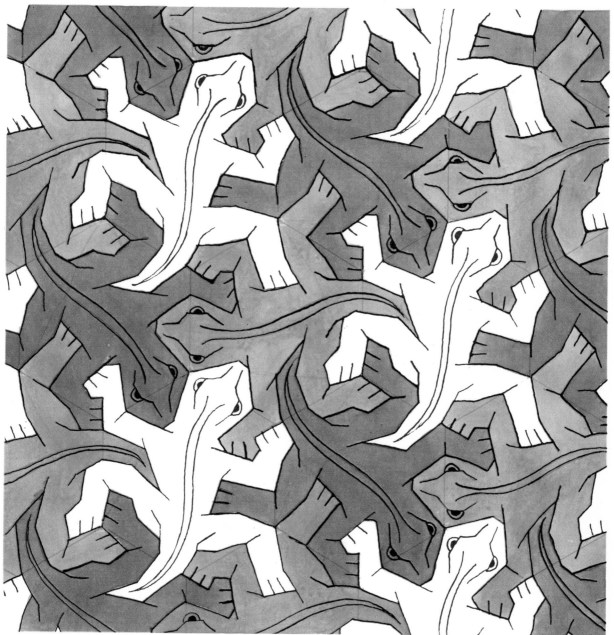

PLATE 38

Plate 39

This pattern is an example of sixfold rotation with three colours related by symmetry. The most prominent symmetry elements are plain twofolds, between the tail tips of two lizards of equal colour. At these same points two right paws of lizards of another colour meet; the twofolds occur in surroundings of three different colour combinations.

Mark all the seventeen twofold points in the pattern; they are equivalent by colour symmetry. Note that they are arranged in a net of equilateral triangles and regular hexagons. In the middle of each triangle is a threefold rotation point, changing the colours in the order white-red-black for each clockwise rotation through 120°. In the centre of the hexagons we expect, and find, sixfold rotation points. These combine the colour scheme of the threefolds with the plain rotation character of the twofolds, resulting in a colour order white-black-red-white-etc. for each clockwise rotation through 60°.

It is interesting to compare the pattern with Plate 27. Both are colour variants of the plain sixfold symmetry p6; they have the same system of sixfold, threefold and two-fold rotation points. In 27 rotation about the sixfolds is coupled with alternation of the two colours black and white, leading to plain threefolds and coloured twofolds, because these are the colour characteristics of rotation of $2 \times 60°$ and $3 \times 60°$ respectively about the sixfold points. On the other hand, if a rotation of 60° leads to a permutation of three colours, as in the present case, then the original colour is restored after rotation of $3 \times 60° = 180°$, so that also the subsidiary twofolds in the cell give 'plain' rotations, whereas the threefolds are all coloured.

Note how Escher has used practically the same motif to achieve the patterns of Plates 38 and 39 with different packing and symmetry. Clearly the lizards of Plates 16 and 25 are also closely related. We meet the same sort of phenomenon in crystal chemistry, where sometimes quite awkward-looking organic molecules manage to crystallize according to different packing laws, forming polymorphs with often small difference in stability.

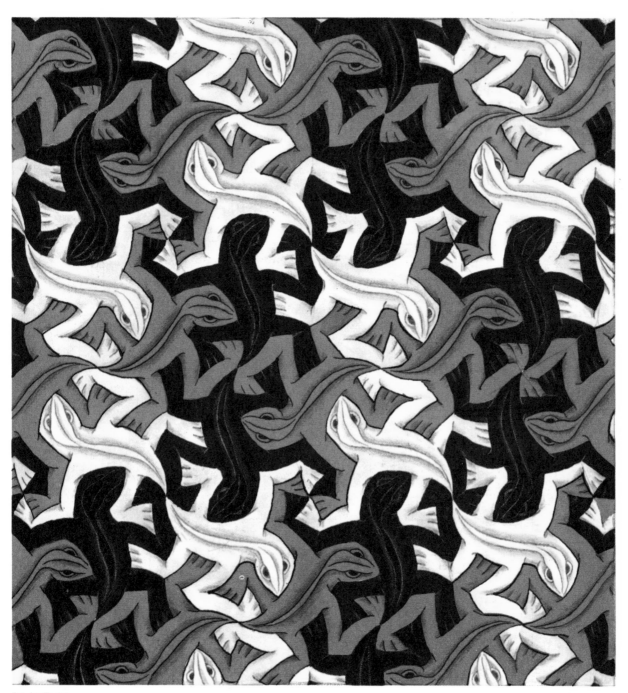

PLATE 39

Plate 40

Compare this pattern with Plates 9, 8 and 36. It has the same 'plain' symmetry as Pattern 9, namely, when we consider black, grey and red tadpoles as different animals altogether. There are then three different threefold points on the long diagonal of a cell with e.g. 'black' threefolds at the corners. Mirror lines run through the long diagonal of the cell and its symmetry-equivalent directions. However, the animals of three different colours are all of the same shape, orientation and surroundings, so that they are interconverted by a three-colour translation along the long diagonal, just as the three unicorns in Plate 36. Even the glide lines parallel to this translation, with their mixed plain and colour character, are present. We can define a 'colour' cell, $\frac{1}{3}$ in size of the plain cell, with four plain threefold points at the corners, differing in nothing but colour scheme of their environment. This small trigonal cell must again have threefolds at $\frac{1}{3}$ and $\frac{2}{3}$ of its long diagonal, and these must permute the colours black, grey, red. (Disregard the eyes of the animals which are all the same colour.) The colour-threefold points are found where three paws of different colour come together. They are each others mirror image by the symmetry line along the short diagonal of the colour cell. The colour cell is therefore analogous to the cell of Plate 8, whereas the arrangement of mirror lines in the plain cell is the same as in Plate 9.

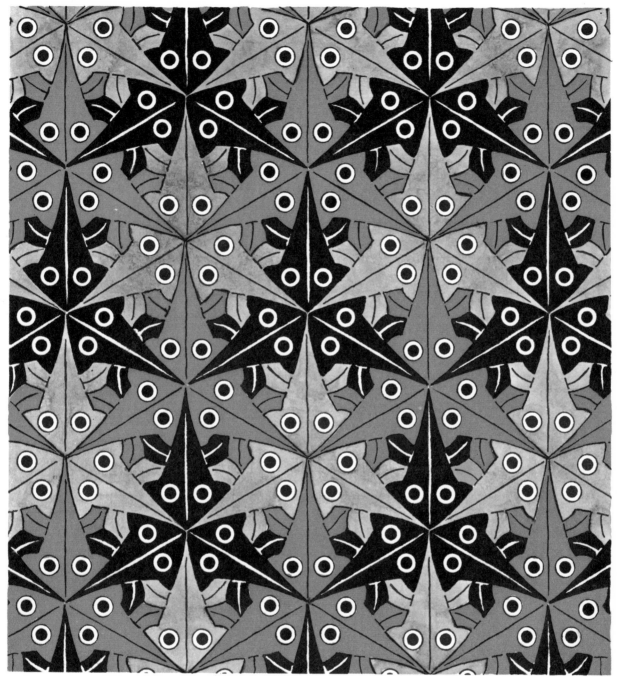

PLATE 40

Plate 41

This most complicated three-colour pattern is similar to the preceding one in showing a threecolour translation in a net of equilateral triangles. There is no mirror symmetry here. On the other hand, the plain threefolds are also points of sixfold colour symmetry. Each of these points leaves one colour invariant and interchanges the other two. Therefore, between two subsequent sixfolds of one 'colour', there must be a twofold of the same colour characteristics. These same twofolds, being also halfway between two sixfolds of different colour, interchange the colour schemes of the latter. The colour threefolds are of the same type as in the previous pattern.

Perhaps a more logical, though more abstract, interpretation of the colour symmetry in this pattern is the following. The 'asymmetric motif' is clearly a three-coloured moth. It occurs in six different colour combinations, as given in the following table:

	A	B	C	D	E	F
body	yellow	red	brown	brown	red	yellow
front wings	red	brown	yellow	red	yellow	brown
back wings	brown	yellow	red	yellow	brown	red

A, B and C are interchanged by a cyclic permutation of the three colours, and so are D, E and F. We arrive from an element of the first set to one of the second by an anticyclic permutation of colours, i.e. a change of two colours only.

The six- and twofold points interchange two by two an element of the first and one of the second set, e.g. A ⇄ E, B ⇄ F, and C ⇄ D. The threefolds, non-sixfolds, carry out cyclic permutations A, C, B, A, etc., and F, D, E, F, etc. So the pattern could have been made with unicoloured moths in six different colours, corresponding to the six different types A, B, C, D, E and F.

Symbolically, we can compare the threecoloured moths with atoms or molecules having three properties ('body, front wings, back wings') which can assume three different values ('brown, yellow, red'). The values of these properties should not affect the packing in a crystal structure and could be not easily detected by physical methods. If they are detected, then we find the colour symmetry, and distinguish between colour and plain translation; if the physical methods fail to distinguish between the different atomic states, then we find the small sub-cell, which is in reality a colour cell. Cases of such multiple 'crypto-symmetry' have been treated in the literature.

A further analysis of this highly intriguing pattern has been given by A. L. Loeb, *Color and Symmetry* (l. c., p. XI).

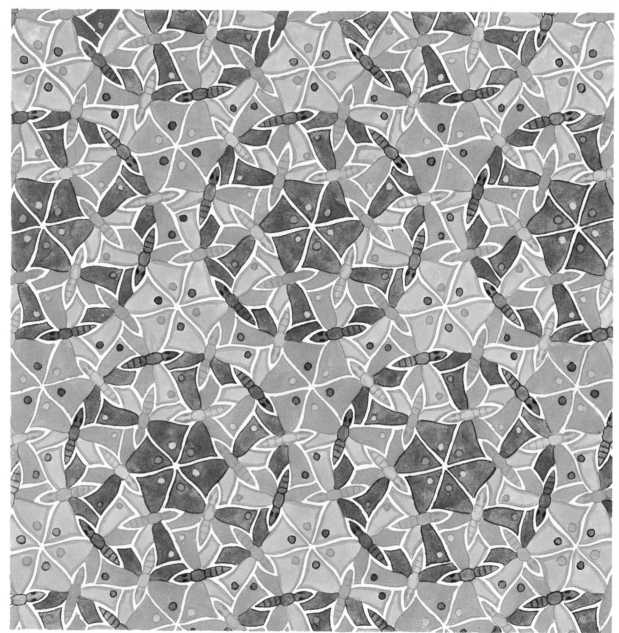

PLATE 41

Index

of some Crystallographical Expressions

The number indicates the Plate in the discussion of which
the expression is defined or mentioned.